BAGNALL, ENDON, STANLEY & STOCKTON BROOK

THROUGH TIME

Neil Collingwood

AMBERLEY

Acknowledgements

I acknowledge The Ashes, Malcolm Bailey, John Bebbington, Sheila and John Berrisford, The Black Horse, Endon, Gilbert Brammer, Blabe Morgan LLP, Peter Buxton, The Capture Factory, David and Linda Clews, Ellen Clough, Corinthian Stone, Stanley, Mr and Mrs Alan Dodd, The Endonian Society, Lisa M. D. Edwards, Jean and Malcolm Fletcher, Geoff and Jean Fisher, Sue Fox, Adam Geens, Greenway Bank Golf Club, Ann and Don Hancock, Peter Joddrell, Alan Payne, C. Geoff Perkin, Mrs Joan Pickering, John and David Pickford, Ben and Sarah Reeves, Kenneth G. and Suzanne Simpson, The Sportsman, Stockton Brook, The Stafford Arms, Bagnall, Stanley Head Outdoor Education Centre, St Chad's Church, Bagnall, St Luke's Parish Church, Endon, Stockton Brook Bowling Club, Tomkin United Reform Church, The Travellers Rest, Stanley, Johnny Walker, Alan Williamson, Sue and Chris Wilson.

My sincerest apologies if I have unintentionally missed anyone from this list.

And finally, with especial thanks to David Peter Daws, the sort of friend that everyone would want, but very few are lucky enough to have.

First published 2015

Amberley Publishing
The Hill, Stroud, Gloucestershire, GL5 4EP
www.amberley-books.com

Copyright © Neil Collingwood, 2015

The right of Neil Collingwood to be identified as the Author of this work has been asserted in accordance with the Copyrights, Designs and Patents Act 1988.

ISBN 978 1 4456 5363 1 (print)
ISBN 978 1 4456 5364 8 (ebook)

British Library Cataloguing in Publication Data.
A catalogue record for this book is available from the British Library.

Typesetting by Amberley Publishing.
Printed in Great Britain.

Introduction

Although arranged to spell out the name BESS for ease, the four villages in this book will be examined as though the reader is taking a circular tour beginning and ending on the north-eastern edge of Endon.

Travelling from Longsdon along the busy A53 towards the Potteries, the first parts of Endon that the visitor sees will be the parish church of St Luke's, high on a hill ahead and the imposing stone house 'The Ashes' on the right, now a top venue for weddings and their receptions. Just past the Ashes, close to the Black Horse public house, is the unusually named 'The Village', actually a lane that climbs upwards to the old village of Endon, with its wells, ford, footbridge and old Wesleyan Methodist chapel. The village is a beautiful tranquil place and fortunately is still largely occupied by local people, some having lived there from birth. At the end of May, every year there is a well-dressing there where the wells are decorated with brightly coloured flowers making up topical pictures and moral sayings. This practice is fairly unusual in Staffordshire and is more often associated with neighbouring Derbyshire. The well-dressing and its associated festivities cause the village to be inundated by visitors to the well, not unlike when the same area was inundated by water in the 1927 floods, but more of that later.

Crossing the ford along Brook Lane takes the visitor past the ancient Sutton House and the pedestrian steps to St Luke's Church and then down Endon Bank to the junction with the A53, next to the Plough Inn. A short distance to 'The Fountain' and a left turn down Station Road leads to the village hall, the old station (now a café), shop, audiology centre, doctor's surgery and chemist. Beyond is Post Lane, passing the cricket club and over the Caldon Canal via the narrow bridge with its traffic lights that 'see' you and change to green as you approach (unless a car is coming the other way of course). Next comes Stanley Bank leading either directly to the village of Stanley, or via a right turn along Stanley Road. Travelling down Stanley Road between the large houses on either side brings the visitor to the old Hercules Mill, now Corinthian Stone, on the right and its former millpond on the left. Like the old village of Endon, this area was severely affected by flooding in 1927 when Hercules Mill was extensively damaged. To the left is Puddy Lane, very narrow and with a blind hump-backed bridge crossing over the outflow from Stanley Pool, a reservoir built to feed the local canal network and in the process powering a number of different watermills. It was events at Stanley Pool that led to some of these mills being damaged or destroyed in 1927. On 11 and 15 July, two severe storms hit the area, which caused Stanley Pool to fill rapidly to capacity and the water then broke through, over and around the earth dam to cascade down the course of the outflow, damaging buildings and killing livestock as it did so. Fortunately because, as the storm progressed, local people were aware that this was going to happen, no one was killed. At the same time that chaos was caused by the flooding in Stanley, Endon too was in the path of flash flooding from the steep hillsides above the village and causing severe damage, but again no loss of life took place there either. Stanley Pool now boasts Stanley Head Activity Centre, where disabled and disengaged children can go to learn sailing, climbing and other outdoor activities.

Stanley does not have its own church, being part of the Parish of Endon-with-Stanley. It does, however, have what used to be St Agnes's Mission until the 1990s, connected to

St Lukes' Church, Endon, and now part of a private house. Stanley like 'old Endon' is a beautiful village, its houses largely built of local stone and very '*des-res*'. There is a thriving village pub – The Travellers Rest – run in the past by three generations of the Mould family, which slowly annexed adjacent cottages to become larger. Today it is popular with visitors and locals alike, taking lunch or dinner there, and its outside tables are packed in the warm summer months. Unlike Endon, Stanley no longer has its own shops.

Bagnall can be reached in several ways from Stanley and is another picturesque residential village. Bagnall too has no shops or post office, but as it is outside the parish of Endon-with-Stanley, it does have its own church, called St Chad's. It also has a beautiful restored cross, probably dating from the sixteenth century, on The Green, but, rather unfortunately, many visitors may pass through the village without ever spotting it, obscured as it is in summer by five Chestnut trees planted on Queen Victoria's Jubilee in 1897 and named for her daughters. Bagnall has a hall, although not large, which is an eighteenth-century replacement for an earlier building. Like Stanley, Bagnall has its traditional country pub/restaurant, the Stafford Arms, again increased in size over time by the annexation of cottages and outbuildings. At the end of the Stafford Arms stands St Chad's House with its unusual stone-roofed bay and formerly the Rectory to Bagnall Church. On the outskirts of Bagnall is Bagnall Spring next to a ford.

Although there are plenty of old buildings in Bagnall and Stanley, postcard photographers clearly felt starved of good subjects, making some of the postcard images they took among the most unusual and uninteresting that can be imagined.

Clewlows Bank takes the visitor back down from Bagnall to Stanley Road, ending opposite the Rose & Crown pub. A left turn leads to Stockton Brook via the narrowest of road bridges over the Caldon Canal, which here is at its summit. On the north bank of the canal is a beautiful Georgian house that sadly has been in a derelict state for decades and would grace the village if its restoration was ever completed. Stockton Brook is lucky enough to have two pubs, The Hollybush, now more of a large-scale restaurant and the more traditional Sportsman. It also has a shop and post office, gents' hairdresser and beauty salon. There is also the remains of a station on the old Leek–Stoke-on-Trent line, for many years a newsagent but now occupied by a kitchen and bathroom retailer.

A right turn by the old station takes the visitor along the A53 through 'new' Endon and from there back to the Black Horse and where this circular tour began.

Throughout the entire area, there is a plethora of desirable and often large Victorian villas, ancient farms and quaint cottages. The four villages are idyllic places to live despite being only a stone's throw from the bustling Staffordshire Potteries with its 'five towns' – or is it six? The busy A53 carries the majority of the residents to work either in Leek or in the Potteries, but fortunately, there are still some gaps in the housing in both directions. Let's hope that these gaps can be retained and that the villages remain villages rather than simply becoming suburbs of Stoke-on-Trent or Leek.

For anyone who wishes to know more about the area covered here, the author suggests contacting the Endonian Society, which holds meetings and keeps a large archive of items relating to the area.

Neil Collingwood,
September 2015

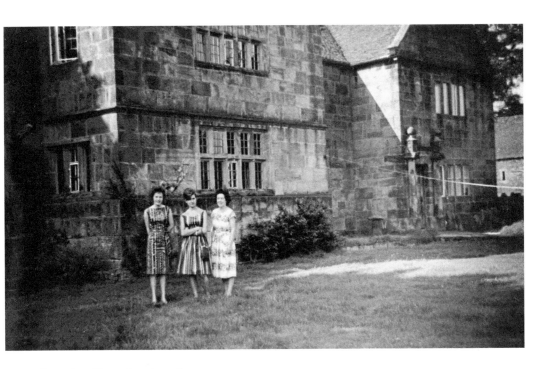

The Ashes (front,) early 1960s

This photograph shows Evelyn 'Bessie' Williamson and two friends at the front of The Ashes dressed for a night out *c.* 1960. The Ashes was built in 1560 and passed through many hands before being taken over by the Williamson family *c.* 1900. Bessie herself remained farming there until in her 90s. Built to an 'H' shape, The Ashes gives the impression of intending to weather north Staffordshire winters for millennia. Its restored sixteenth- and eighteenth-century barns are now used to host wedding celebrations.

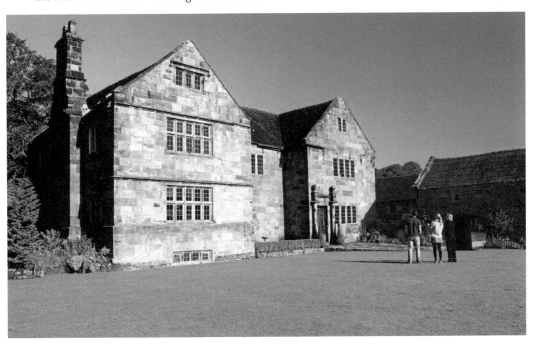

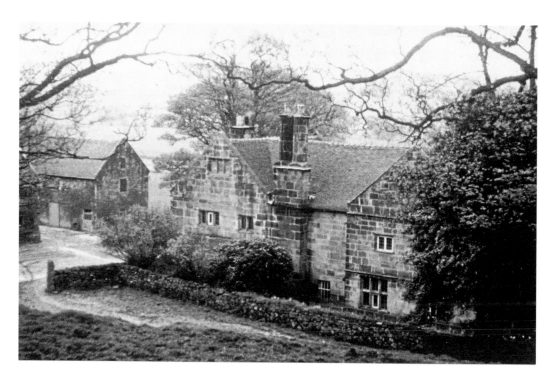

The Ashes (rear), Undated

This undated photograph shows The Ashes from the rear access drive. Today The Ashes has been restored to create both a luxurious family home and a multi-award-winning wedding venue, hosting exclusive wedding celebrations throughout the year. The long drive leads visitors past the large ornamental lake with its geese, ducks and Little grebes and up to the warm-coloured stone buildings. Like many of the ancient buildings in this area, The Ashes seems worthy of a book of its own.

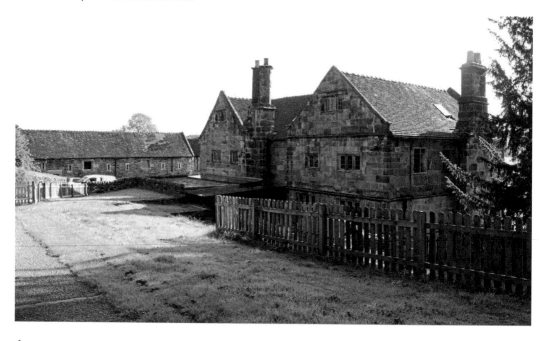

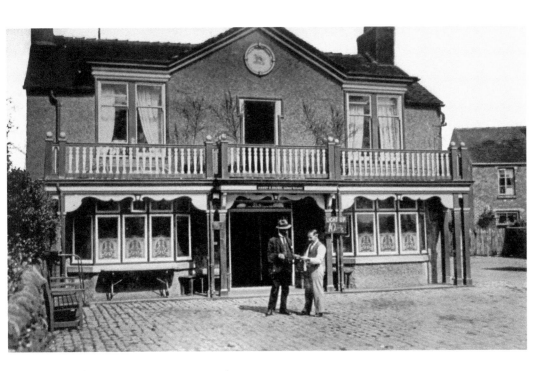

The Black Horse, c. 1930

This is the second Black Horse in Endon, the first, in existence by 1802, overlooked the brook (see page 26). This building was substantially altered in c. 1936. The Black Horse was a popular stop for cyclists, and the blackboard by the door indicates lighting-up time. Cyclists of that time would no doubt have been astonished at the speeds achieved by the Tour of Britain cyclists as they flashed by in September 2015 en route from Hanley to Nottingham via the Peak District.

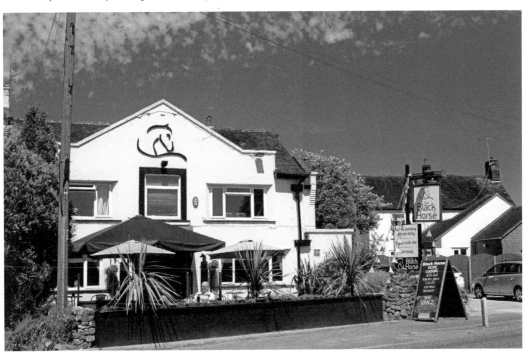

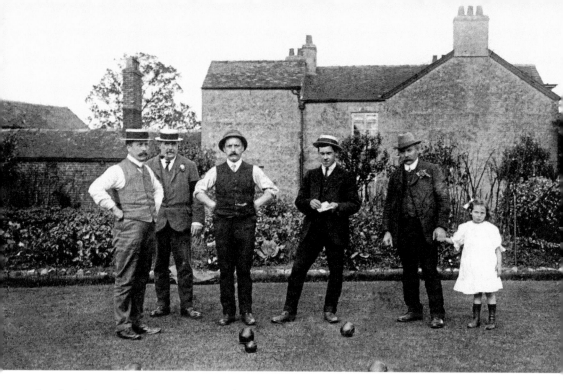

Bowling Green at Florence House, Early 1900s

This photograph shows a group of men including Mr Frank Thiemicke, playing bowls at Florence House. Mr Ludwig Carl Francis 'Frank' Thiemicke was originally from Dessau in Germany. He named his house, his garage, a terrace in The Village and the tennis club across the road after either his wife Florence (Wood) or his daughter Florence who was born in 1903. The building in the background is the Black Horse with its outbuildings, most of which were demolished in *c.* 1936.

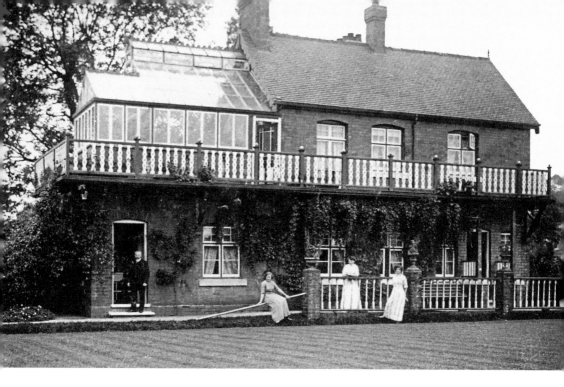

Florence House, Early 1900s

Florence House was the home of Mr Thiemicke and was unusual having a large conservatory on the first floor. This was later removed and replaced by a conventional brick 'upstairs'. The house stood end on to Leek Road adjacent to the village garage, originally Florence Garage. The house was also unusual in that it had its own bowling green. The house later became the Priory Café, and when that was demolished, a cul-de-sac of houses was built on the site named The Priory.

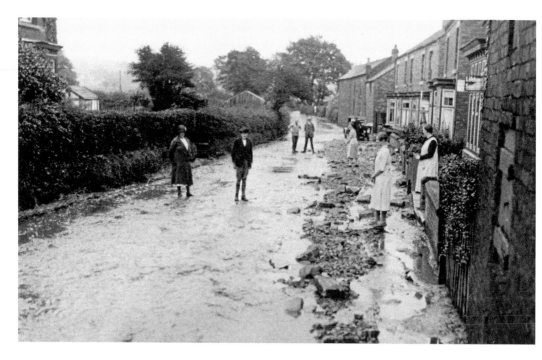

Florence Terrace, 1927

A major event in Endon's history was the floods that occurred in July 1927. Two torrential rainstorms in the same week caused flash-flooding which ran down the slope above the village and into the brook. The brook overtopped its banks, the deluge destroying the footbridge next to the forge and sweeping down The Village towards Leek Road. This photograph shows the water still flowing after the initial surge that had deposited large lumps of stone in front of Florence Terrace.

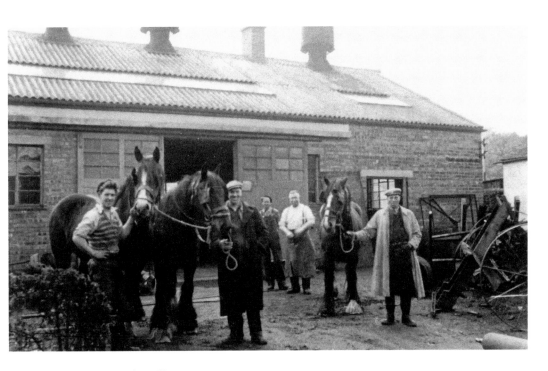

The New Forge, The Village, 1952

This photograph shows staff and customers at the 'New' Forge in The Village. Second from the right is Mr Charles Perkin who had the forge built in 1947, having outgrown his earlier forge near the brook (see pages 27 and 28). (Charles) Geoff Perkin succeeded his father in the business, and when Geoff retired in 1998, the business was continued by his last apprentice. The four houses on the new photograph, called Nos 1–4 The Forge, have now replaced the forge.

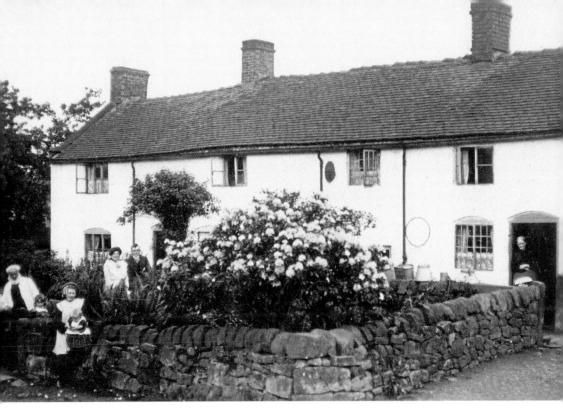

The Cottages, The Village, 1905

The cottages shown in the old photograph are still standing although significantly modernised and extended since 2013. They are now known as Nos 1–3 Rose Cottage(s). The people shown in the old photograph are believed to be relations of Dave Clews of Church Bank. The New Forge (see previous page) was built to the left of these cottages in 1947. After the forge closed in 2003, it was demolished, and a row of four new 'cottages' was built on the site.

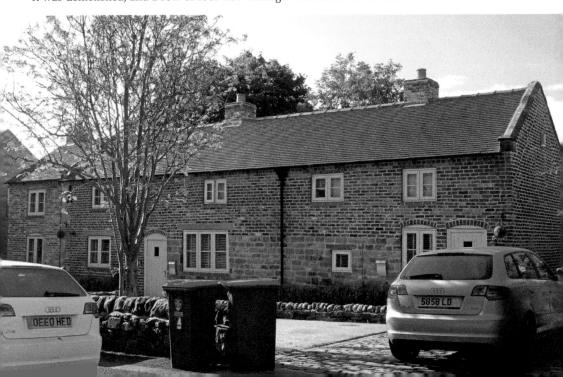

Endon Post Office, The Village, 1960s
This pair of houses was allegedly purpose-built by the Baddeley family, the right-hand one to be a house, post office and single-storey cobbler's shop. When the cobbler's closed, it was converted into a garage. The only signs today that the post office was ever here are the name The Old Post Office and the post box standing just out of shot. The post office closed in 1982, the nearest one today being at Stockton Brook, one and a half miles away.

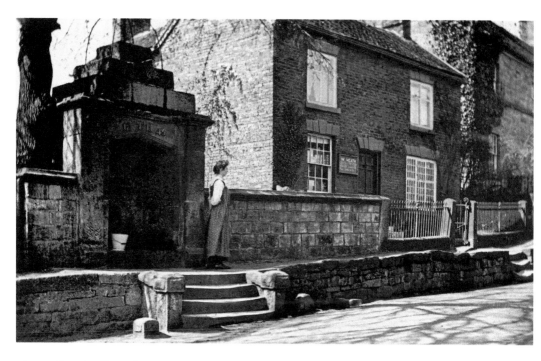

The Well and Village Shop, Endon Village, *c.* 1910

This old photograph shows the village well (actually a fountain) donated to the village in 1845 by Thomas Heaton, a local landowner. The young lady standing next to the structure was almost certainly added by the photographer purely to add a touch of style and glamour to the photograph. To the right of the well stood the shop run by William Heath, a 'General Provisions Merchant, licensed to sell tobacco'. This is now a private house called 'Spring Cottage'.

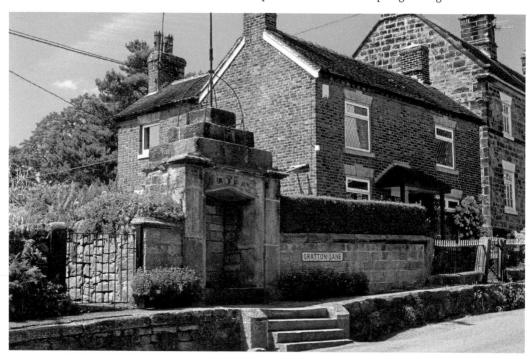

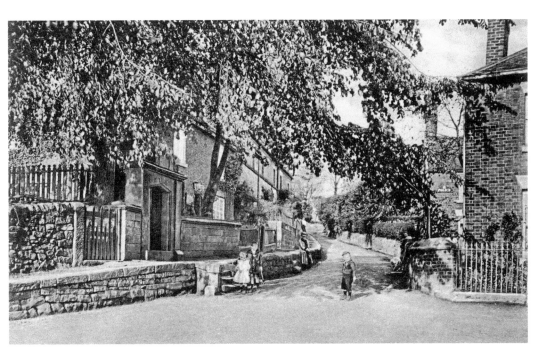

Endon Village Wesleyan Chapel, c. 1912

Endon Wesleyan chapel, just visible on the right, was built in 1835 and closed when the new chapel on Leek Road opened in 1875 (see page 44). The single-storey chapel was then converted into two cottages which involved jacking up the entire roof and inserting a new first floor. A slight mishap at the end of the process resulted in the roof being lowered slightly out of alignment, something that is still detectable today. The Police house is visible higher up Gratton Lane.

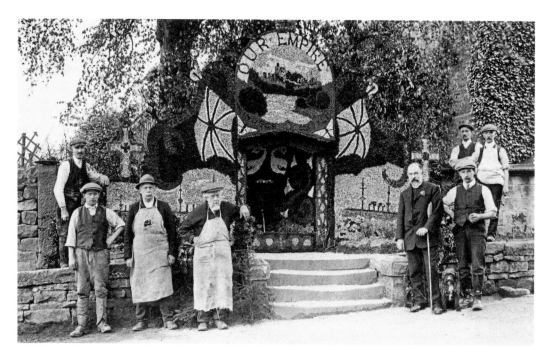

Endon Well-dressing, 1913

Since 1845 when Thomas Heaton had the stone well house built, the weekend closest to 29 May heralds Endon's well-dressing. Well-dressing is more a Derbyshire tradition but formerly also took place at Rushton Spencer and Cheddleton, although now discontinued at both. A well is 'dressed' by creating colourful pictures and messages using live flower heads pressed into wet clay boards. The carefully designed pictures highlight local scenes or celebrities accompanied by moral messages. How many of these men never saw another well-dressing?

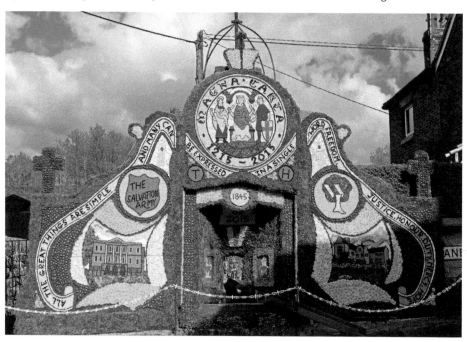

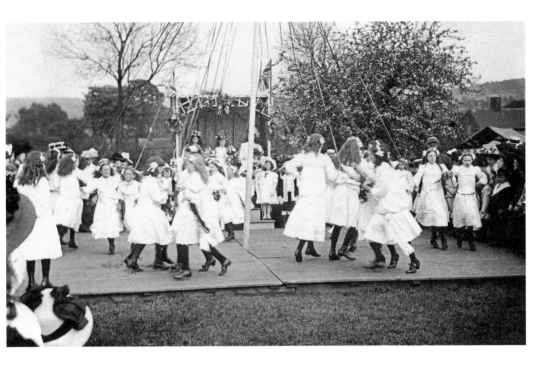

Maypole Dancers, Endon Well-dressing, 1909

This is a case where modern colour photography outperforms Black and White. The way to judge the proficiency of Maypole dancers is by looking at the brightly coloured patterns created by the ribbons at the top of the pole; if these are perfectly regular, then the dancers have performed their steps correctly – this is obvious with colour but not so easy to see in monochrome. Little has changed really at Endon's well-dressing festivities except in terms of the scale of the event.

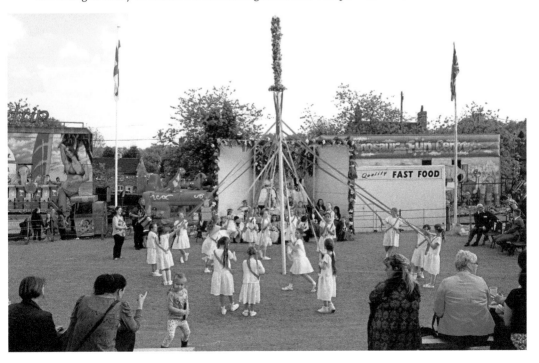

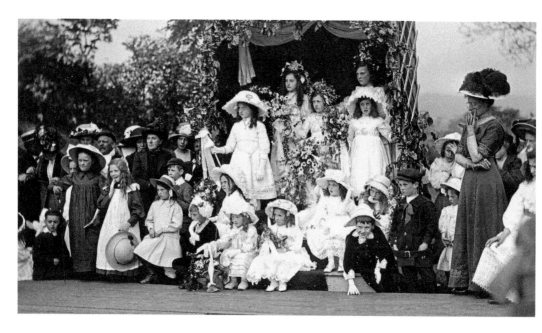

Well-dressing Queen and Retinue, Jaw-bones Field, 1912

Compare the 2015 well-dressing Queen Emily Baines and her retinue to that of R. Broomfield in 1912 and you will see that everything is on a different scale altogether. The well-dressing, now a three-day festival, has taken place in May since 1845 when Thomas Heaton provided village people with a place more convenient for collecting their water than the hole in the ground in the field above, where people had to go previously. Well-dressing may originate from very ancient pagan rituals.

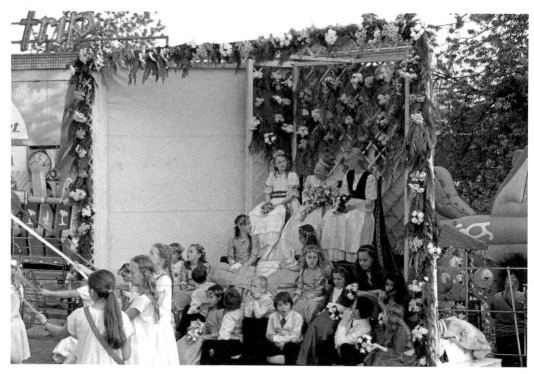

Well-dressing, Outside Jaw-bones Field, 1920s

In this candid 1920s photograph, 'Nan' Griffiths is being alerted to the Endon paparazzi by Revd J. S. Morris. The photograph is taken by a stall just outside 'Jaw-bones field' where the well-dressing festivities take place. The field is so-called because the jawbones of a whale used to form an archway over the gate. Although no longer in situ large segments of these jawbones remain in the village and part of one of them is still hung up during the festival today.

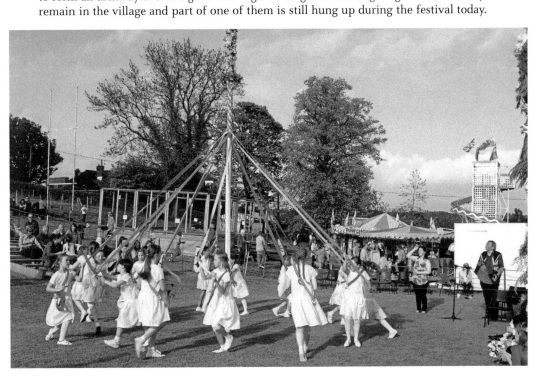

Endon Village from Gratton Lane, Undated

This photograph from Gratton Lane shows the well on the right and the old Wesleyan chapel on the left. The overarching tree that graced village photographs for decades was a Wych Elm, but like so many others during the 1970s and 1980s, it fell victim to Dutch Elm Disease. Despite heroic measures to save it, the tree had to be felled in 1980. Was there perhaps a disagreement regarding whether it should be replaced once the disease had run its course?

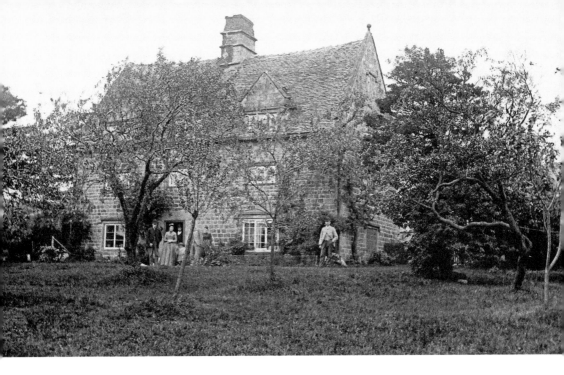

Hollin House Farm, 1880–1890s

Hollin House was built in the 1600s but for decades in the twentieth century was allowed to decline into a very dilapidated state. It was rented out to those farmers and their families who could live with the cold, the leaks and the rot. Eventually, the house was separated from the farm, sold and then sympathetically modernised by the present owner into a seven-bedroom family home. This may be the oldest photograph in the book, possibly dating from the 1880s.

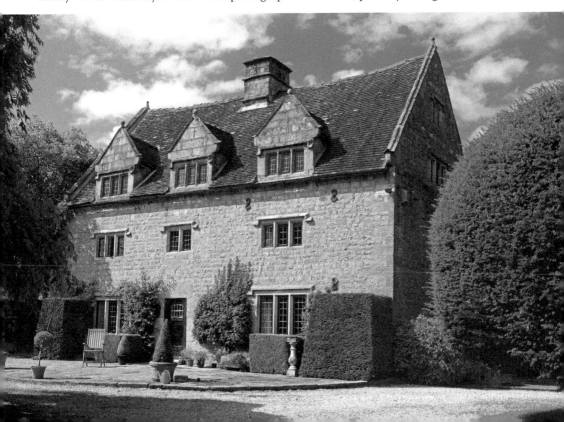

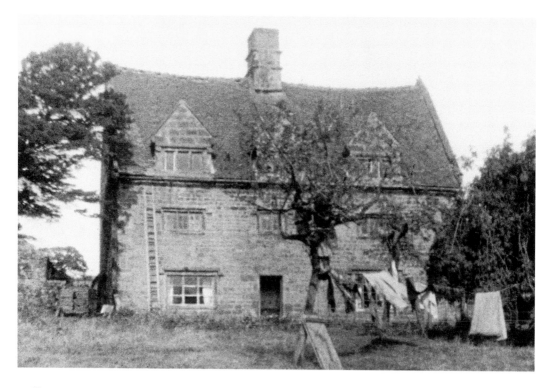

Hollin House Farm, 1960s

This 1960s photograph shows Hollin House when it was rented out and in a very poor state of repair. It had no gas, electricity or running water, and the toilet was of the planks over a bucket variety. So rotten was the fabric of the building that John Holloway, brother of Peter and Jean, who are up the tree in this photograph, fell through an upstairs floor aged only four years and landed in the downstairs parlour.

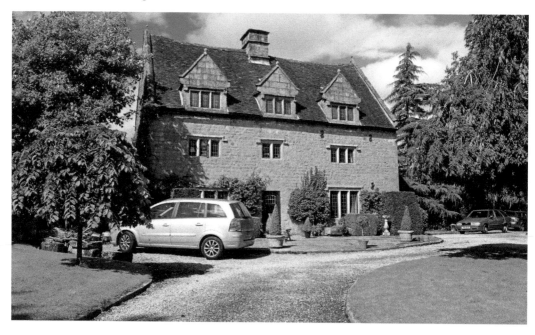

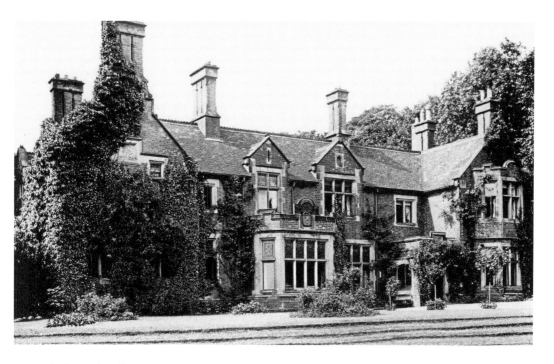

Blackwood Hall, *c.* 1910

On top of Blackwood Hill is a hamlet including Blackwood Hall, a beautiful brick house built in 1885 for landowner John Challenor. The outbuildings include parts of an earlier, stone, Blackwood Hall that was occupied as early as the 1400s by the Wedgwood family, later of Harracles Hall. In 1881, John Challenor occupied the old Hall but by 1891 had retired from farming and occupied the present house with two female servants. The house has recently been restored to its original splendour.

Blackwood Hill Farm, *c.* 1910

Blackwood Hill Farm stands close to the gates of Blackwod Hall and is a modernised half-timbered house. Although the words 'Will(iam) Read' and 'Mar(gare)t Read 1698' appear on the front of the house, the house is believed to be significantly older, possibly dating back to the 1400s. Its historical significance earned it Grade II listing as early as 1952. The book, *The Reades of Blackwood Hill* was published in 1906, the full text of which is available on the internet.

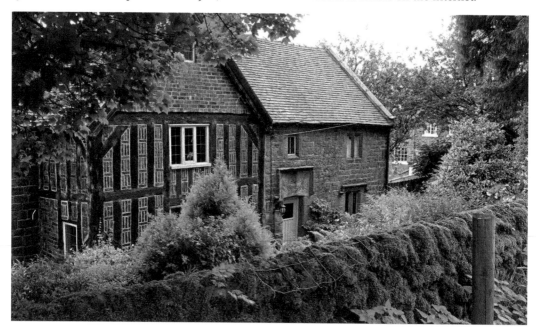

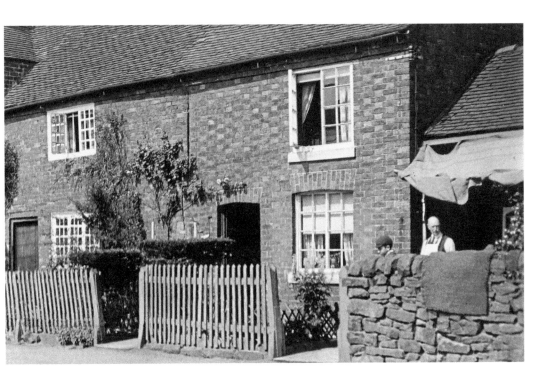

Pickford's Butcher's, c. 1928

This photograph dated *c.* 1928 shows Mr John James 'Jim' Pickford, Endon's village butcher, standing in the doorway of his shop. Jim had founded the business in 1890 and was succeeded by his son – also John James – who lived next door. The shop finally closed in the late 1950s, and the first Jim's grandsons, John and David Pickford, now occupy their grandfather's cottage. In 1977, they demolished the shop and had a two-storey extension sympathetically built in its place.

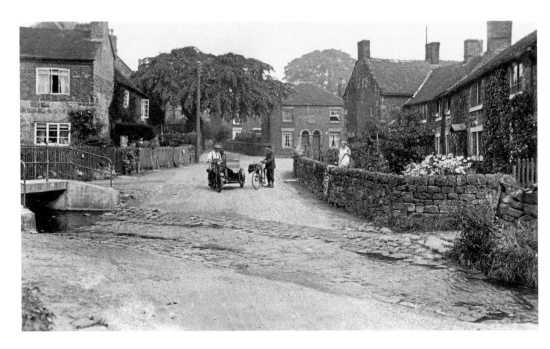

The Ford, Endon, 1930s

This old photograph taken from the road outside the old forge shows the ford and beyond it Charles Perkin, the village blacksmith, sitting chatting from his motorbike and sidecar. On the left behind the bridge is the original Black Horse pub. This building was originally built of stone but was later extended and raised in height using brick. To the right of the road is the row of old cottages, one of which bears the date 1702 over its door.

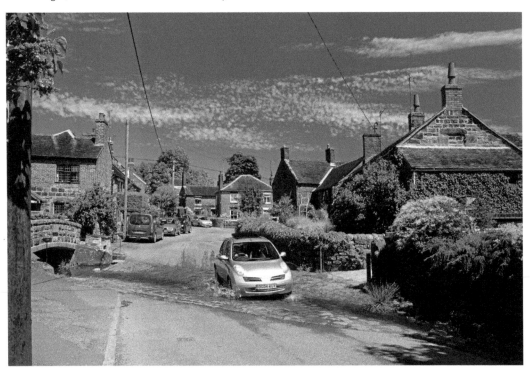

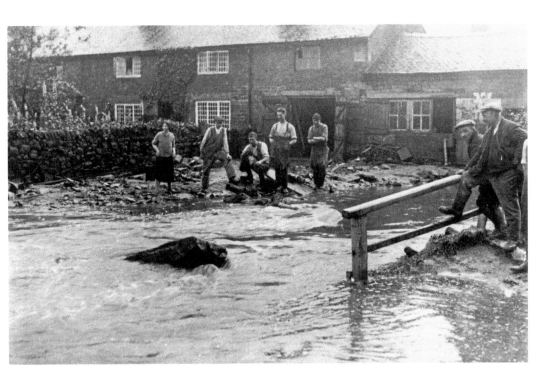

The Floods, Endon, July 1927

In this July 1927 photograph, the blacksmith, Charles Perkin, and his men, together with other local onlookers, watch as the swollen Endon Brook rushes past the forge. The flow of water was so strong that it washed away the footbridge over the brook and the large stone slab protruding from the water is almost certainly the former footbridge walkway. At one time, the cottage to the left of the smithy was a shop.

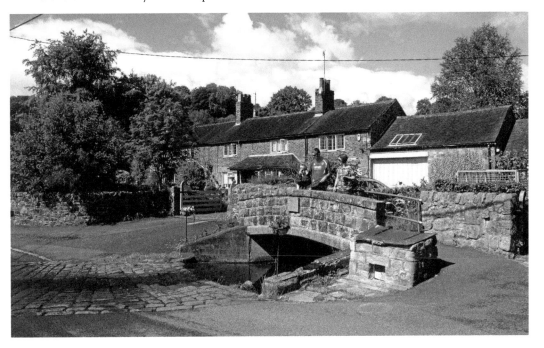

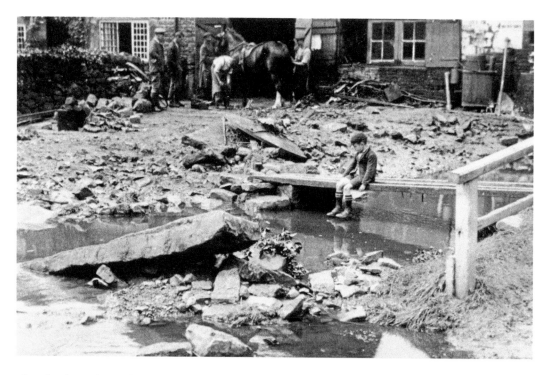

The Floods, Endon, July 1927

In this second photograph of the flood, taken from almost the same place as the one on the previous page, the floodwater level has fallen, and the smithy is back at work. The boy in school uniform sits on the temporary footbridge that has been thrown up and surveys the damage. How much the water level has fallen is demonstrated by how much of the old footbridge walkway is now clear of the torrent.

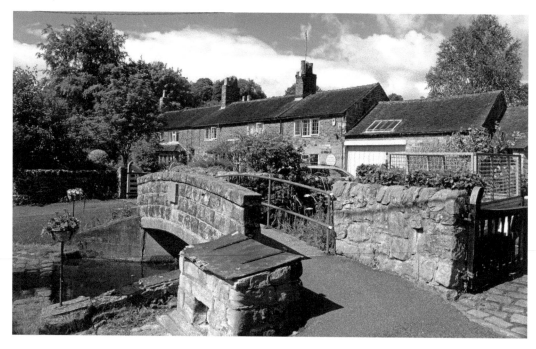

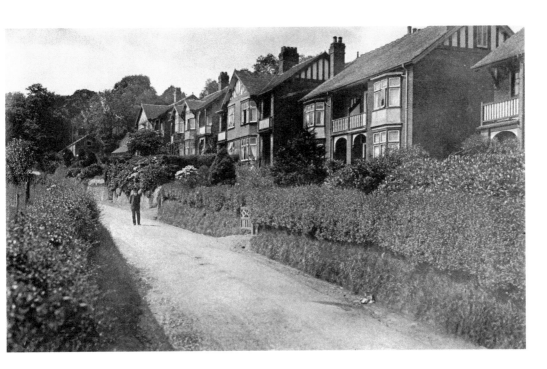

Brook Lane, Looking Upwards, *c.* 1925

Brook Lane leads from the ford to the top end of Hallwater and then onwards, past Sutton House, to Church Bank. It is lined on the right for most of its length by pairs of substantial semi-detached houses, seen here, with attractive gardens. To the right of the smartly dressed man taking his constitutional can be seen a young conifer tree, the same tree that towers above the dog walkers in the recent photograph.

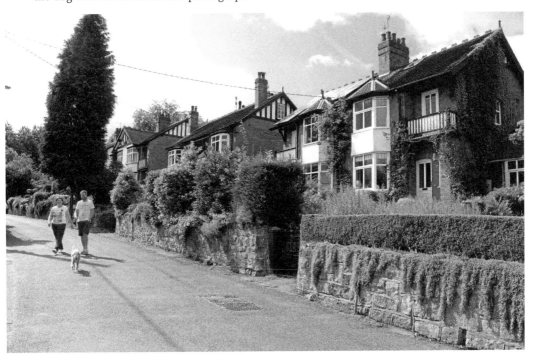

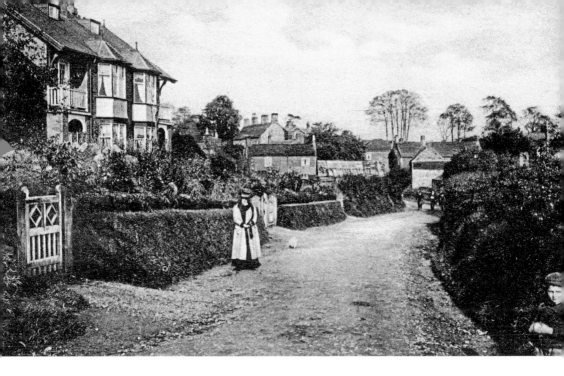

Brook Lane Looking Towards the Ford, *c.* 1912

This old postcard looking down Brook Lane in the opposite direction from the last photograph is one of several that show the same woman, presumably the photographers 'significant other'. She is a youngish woman and probably dressed in the height of fashion for the day, but by today's standards, her clothes appear rather melodramatic and more reminiscent of a First World War spy than an Endonian. The light-coloured building behind the distant walkers was a slaughterhouse belonging to Pickford's the village butchers.

Hallwater Towards Leek Road, Early 1900s

From Brook Lane, Hallwater slopes down past the old tanyard towards Leek Road, the main traffic artery between Leek and the Potteries. Hallwater Farm can be seen on the right. This is about as good as an old postcard photograph can be, beautifully composed and so sharp that it can stand significant enlargement without loss of quality. Someone's little brother sits silent and almost forgotten at the base of a tree, excluded from the 'girl talk'.

Hallwater Towards Brook Lane, *c.* 1912
The young woman reminiscent of Mata Hari (an infamous First World War German spy) makes her third Endon appearance on this Autumnal postcard of Hallwater, looking uphill towards Brook Lane beyond. The tanyard building behind her has a blocked-up archway running right through it. While the actual photography may have been just as good for this card as for the previous one, the quality of the photographer's printing is so poor that the finished image looks as much like a pencil-drawing as a photograph.

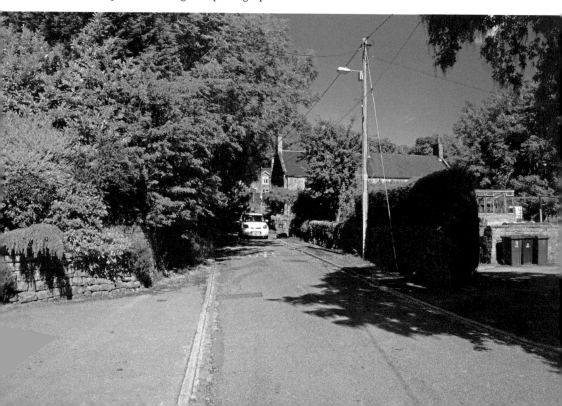

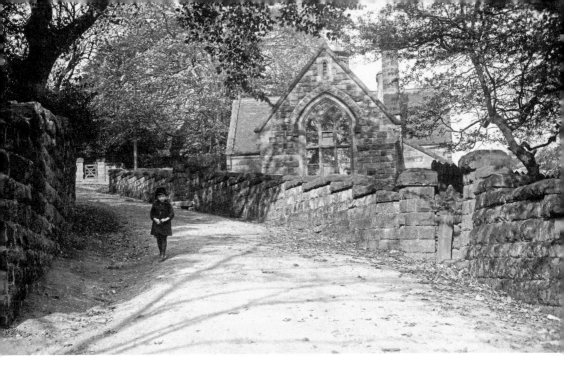

Endon Parochial School, Church Lane, *c.* 1910

Another superb 'Real Photo' postcard image showing the old Endon Parochial School, built in 1871, near to the lych gate of St Luke's Church, Church Lane. When Endon High School opened in 1939, the Parochial School became a junior school until its closure in 1963. Located at the top of a steep hill, the school's foundations were reportedly found to be moving so the decision was taken in 1965 to demolish it. The site is now the church car park.

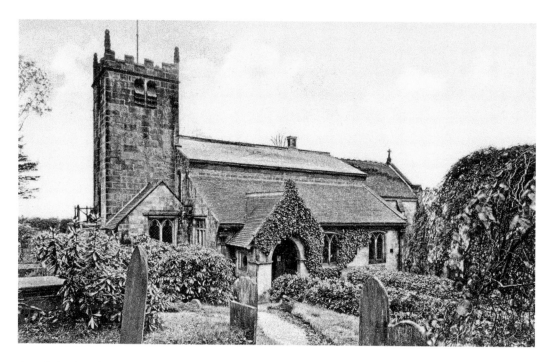

St Luke's Church, c. 1920

The original St Luke's Church was built between 1720 and 1730 as a 'chapel of ease', allowing Endonians to attend services without having to make the journey to Leek. The tower of that church still stands today, but the rest of the church, like so many others, was largely remodelled in the late Victorian period. A further alteration was made in 1971 when the vestry was enlarged, using stone from the old school (see previous page). A linked Chapter House meeting room was also added later.

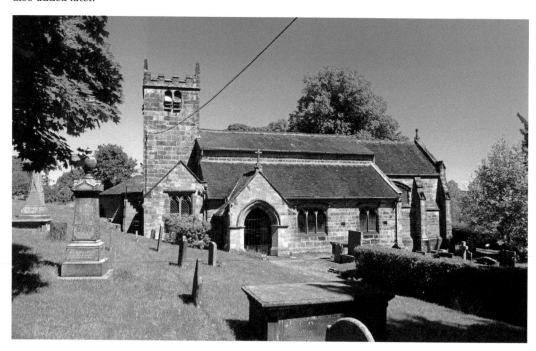

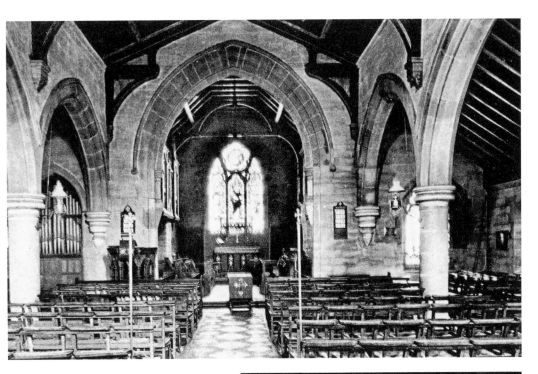

East Window (1893), Endon Church, Undated

This old interior of St Luke's Church has been included because it demonstrates how photographs sometimes fail dismally to show us what they intend to. This shaky old postcard image leads our eyes towards the stained-glass window over the altar attributed to Sir Edward Burne-Jones, (although there seems to be a certain reluctance to state this categorically). In fact, we can see no detail of the window in the old image, but hopefully the new photograph shows what we were missing.

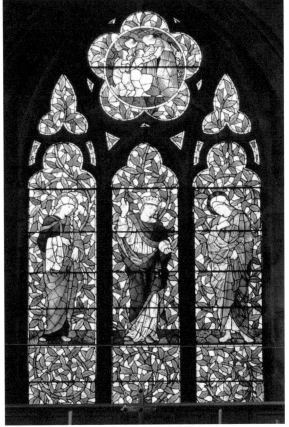

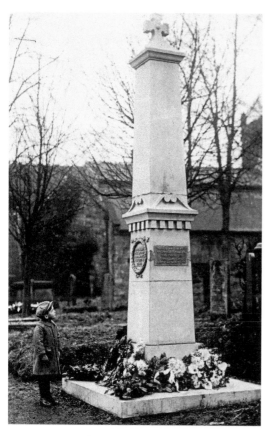

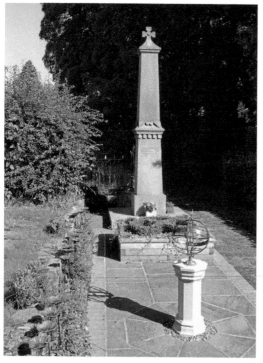

Endon War Memorial, 1920

Endon War Memorial was erected by public subscription *c.* 1920. Here it has probably only just been dedicated and is piled with flowers of all types, the poppy not having been adopted as the emblem of war dead until 1921. In 2014, the centenary of the beginning of the First World War, an Armillary Sphere was placed close to the memorial with the inscription 'Lest generations forget'. A number of ceramic poppies from the Tower of London's *Blood Swept Lands and Seas of Red* installation have now also been 'planted' there.

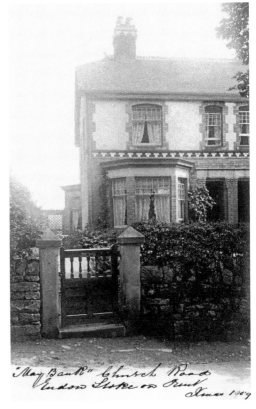

May Bank, Church Lane, 1909

This seems an unremarkable house to feature on a postcard, but it is probably an example of a photograph commissioned by the houseowner from an opportunist photographer. When a place was expanding rapidly and a lot of new houses were being built, local photographers would approach owners to offer their services. Postcards would then be produced which the owners could send to their friends and relatives giving their new address and showing exactly what their new pride and joy looked like.

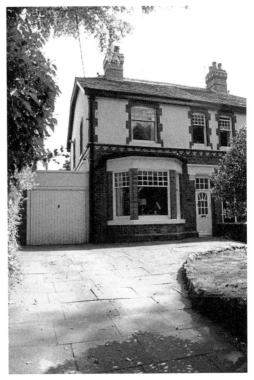

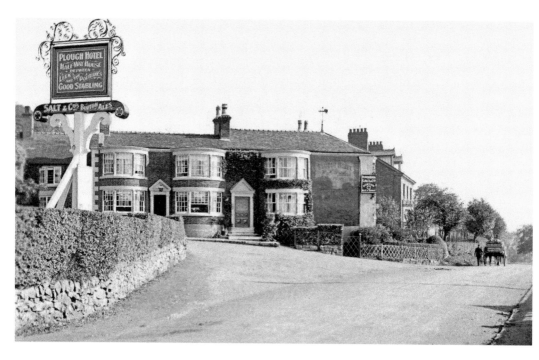

The Plough, Endon

The Plough Inn in the fork between Church Lane and Leek Road has the appearance of a typical eighteenth-century coaching inn but was reportedly originally a private house. It has been open as a licensed inn at least since the 1850s. The painting on the wall, which has been renewed a number of times over the years, is believed by some to be the largest pub sign in England.

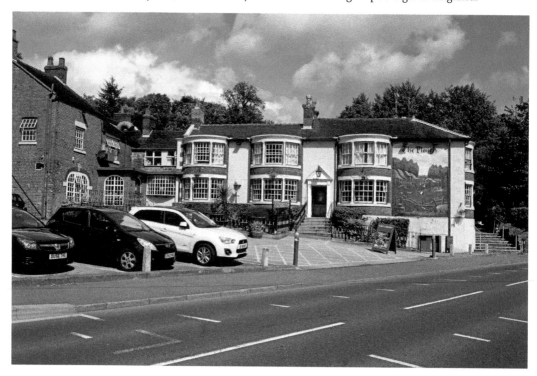

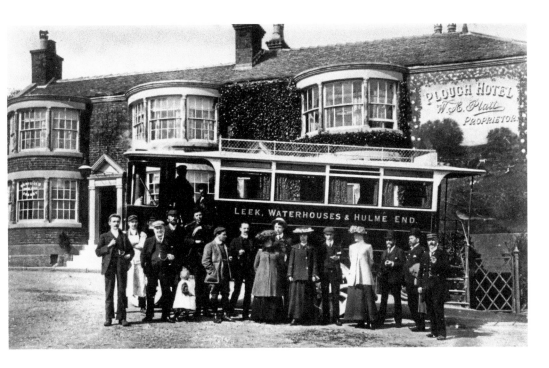

The Plough Close-up, *c.* 1910

In the early years of the twentieth century, when the Manifold Valley Railway was still in operation, a steam bus service operated between Leek, Waterhouses and the Manifold Valley station at Hulme End. Here one of the buses is obviously engaged in an untimetabled excursion to Endon. What is now the car park at the front of The Plough used to be a lawn where customers could sit and have a drink in nice weather.

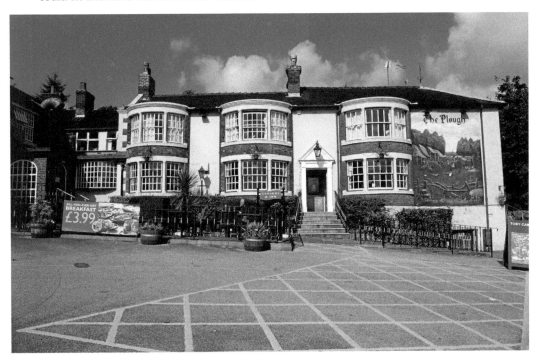

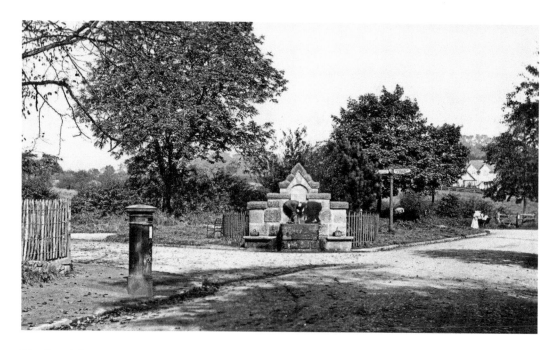

The Fountain, *c.* 1910

There are many postcards showing the drinking fountain erected to commemorate Queen Victoria's Diamond Jubilee in 1897. Perhaps surprisingly, the fountain only survived until the 1930s, allegedly taken down because it obstructed drivers' vision at the junction of the Leek and Brown Edge roads – but why was it not just moved? Despite having been removed around eighty years ago, buses between Hanley and Leek still stop at 'The Fountain' although most of the passengers probably have no idea why the stop is so-called.

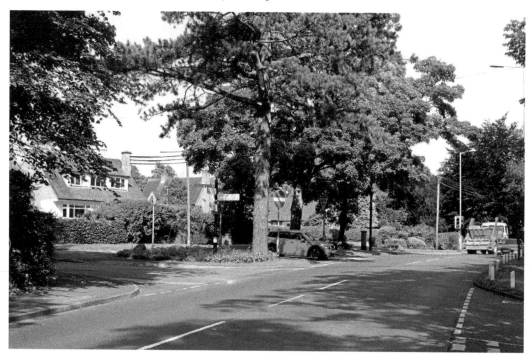

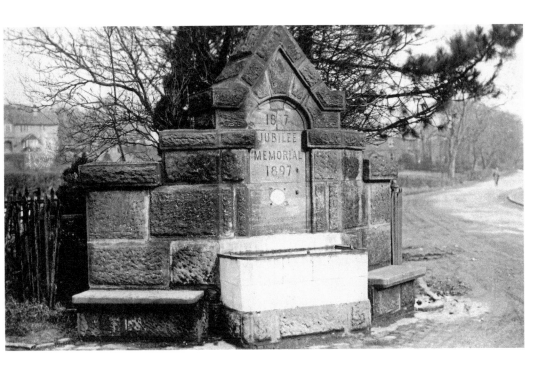

The Fountain, Close-up, *c.* 1912

This close-up of the drinking fountain shows the inscription '1837 Jubilee Memorial 1897', but astonishingly there is no identification of the Monarch concerned; missing are the all-important Victoria Regina, V. R. or the Royal Cypher. By the time this photograph was taken, the water fittings had been removed and the trough was no doubt filled with rainwater. Today the stone inscribed 'Jubilee Memorial' sits beneath the bench near the bottom of Hillswood Drive. The stone sides of this bench are also original parts of the fountain.

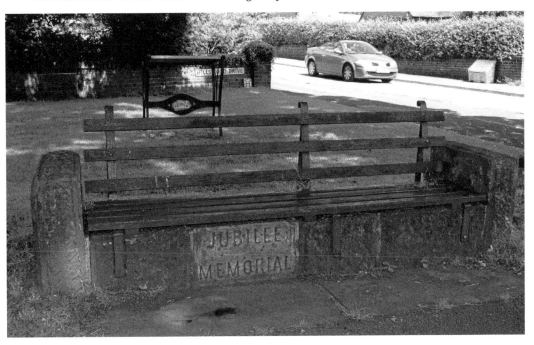

Clay Lake, Towards Brown Edge, *c.* 1920

The road called Clay Lake climbs the hill from The Fountain, bound for Brown Edge. It possibly gets its name from a pool, now surrounded by the mature deciduous trees that divide Clay Lake from houses on Hillswood Drive and Spinney Close. The old photograph shows a rural lane, but today this road is lined on both sides by small enclaves of exclusive housing with large gardens and tennis courts. The white mile marker survives although now hidden in a hedge (see inset).

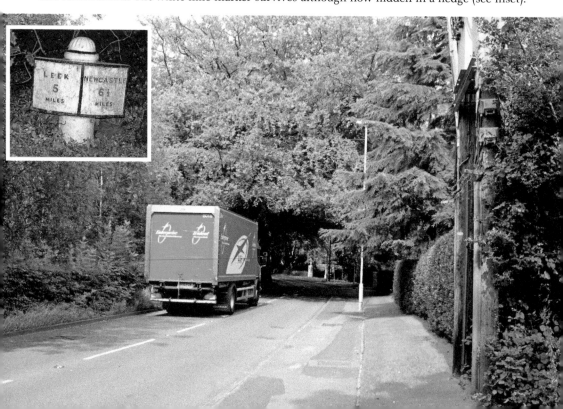

Clay Lake (Little Crofts) Towards Endon, Post-1935

This photograph is lower down Clay Lake than the one on the previous page and is looking towards 'The Fountain'. The photograph must be post-1935 because the road has been fitted with cat's eyes. There is just one vehicle visible on the old image although today there is an almost constant stream of traffic in both directions, especially at school times. The house to the right is Little Crofts that is still there today although now significantly altered and surrounded by other properties.

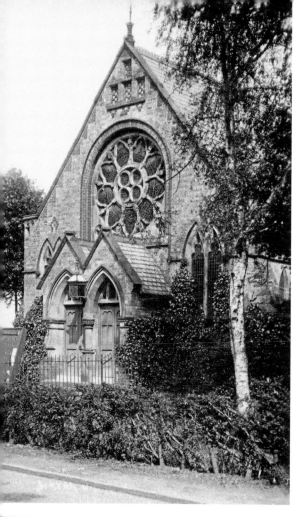

Endon Methodist Church, Undated

This superbly sharp postcard image shows the front of Endon Methodist church built in 1875 to replace the Wesleyan chapel on page 15. The present church, shown in the modern photograph, was built in 1991 to replace its 1875 predecessor. The stonework surrounding the front doors of the 1875 building was retained and rebuilt as external arches, but despite their similarities, the rose window at the front of the new building is not from the earlier church.

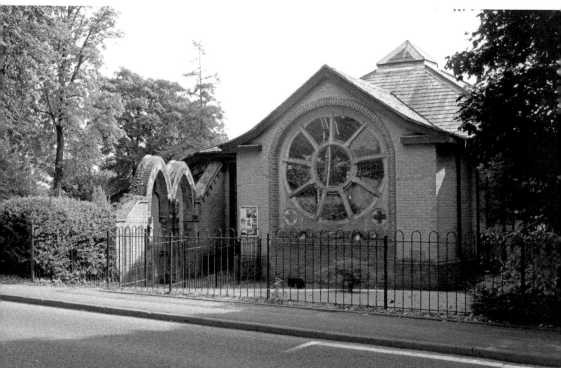

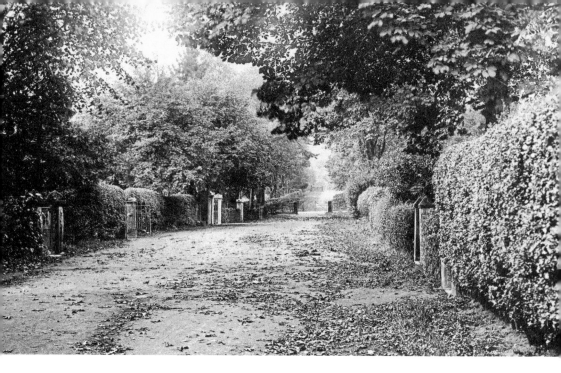

Orford Road, Undated

Orford Road is located close to Endon Methodist Church and has changed little since its houses were built. It is a private road meaning that it has not been adopted by the local authority, and residents are therefore responsible for its upkeep. Today a local authority will only take over a road after it has been surfaced, provided with, lighting, services, etc. by the residents, or if they pay the authority to carry out this work. On the opposite side of Leek Road is another private road called The Avenue.

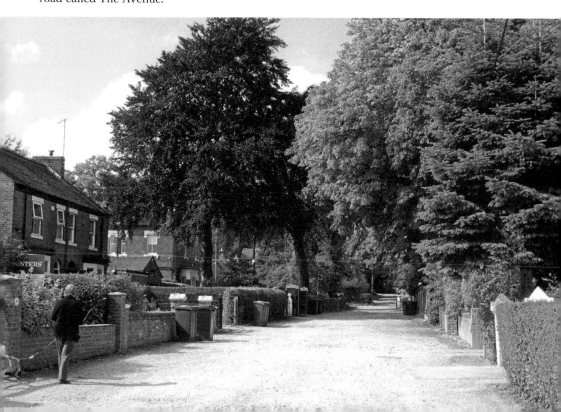

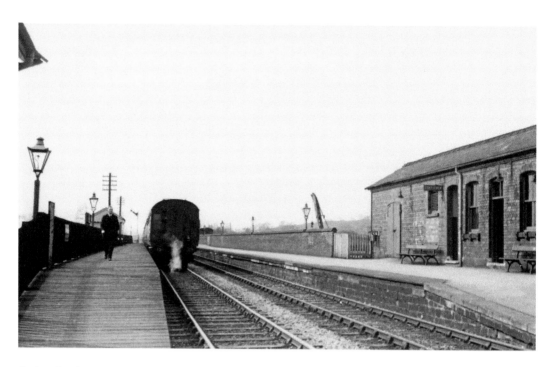

Endon Station, 1950s

Endon Station opened to passengers between Leek and Stoke-on-Trent in 1867. It had two platforms, the right-hand one built of brick and concrete and the left-hand one entirely of wood; this no doubt explains why only the right-hand platform survives. The line was closed to passengers in 1956 but carried excursions until 1963 and freight until 1989. Work is now under way for the station to be reopened by a partnership between Churnet Valley Railway and the Moorland & City Railway.

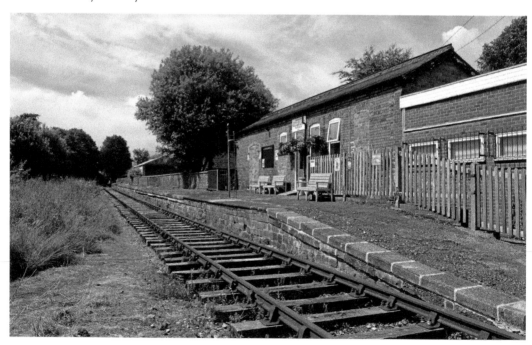

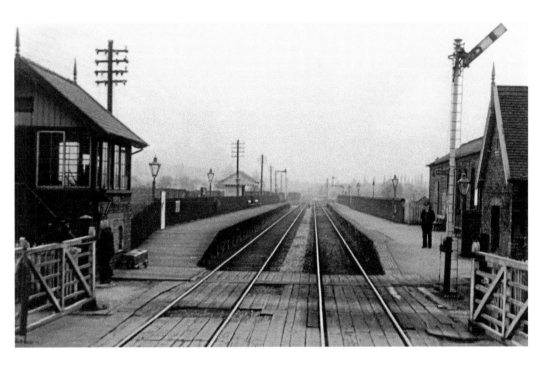

Endon Station, 1952

On the left-hand side of Endon Station was a signal box and a wooden waiting shelter. On the right-hand platform was the ticket office, gents and, presumably, ladies. This brick-built range survives and is now the site of the Station Kitchen – a café with seating both inside and on the platform. The surviving single track has now been cleared in preparation for the station reopening, and new crossing gates and signage have been installed.

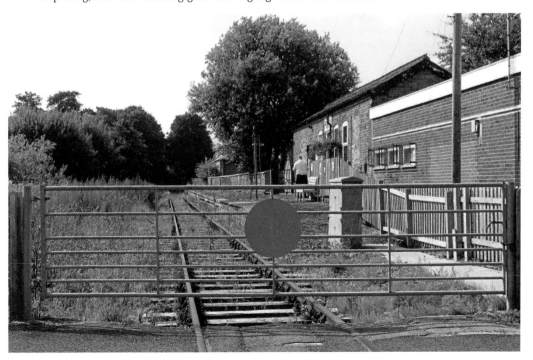

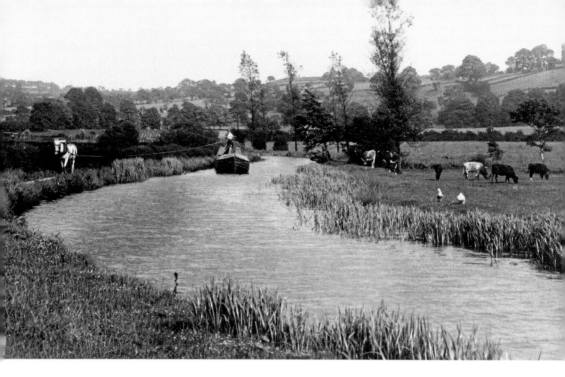

The Caldon Canal, 1937

The old photograph shows a traditional horse-drawn barge in 1937, during the period when commercial canal transport was in terminal decline and leisure-boating had not yet begun. It has been alleged that this is the highest stretch of canal in England, but the Canal & River Trust (who should know) say that it isn't. The Caldon Canal is popular with leisure-boaters today taking them from the Potteries to Froghall via The Hollybush at Denford, Cheddleton Flint-Mill, The Boat Inn and the Churnet Valley Railway at Cheddleton Station.

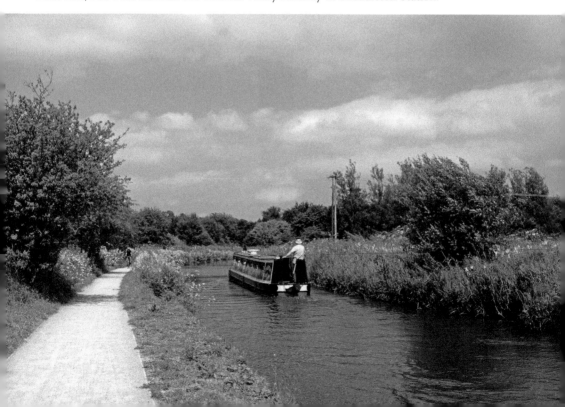

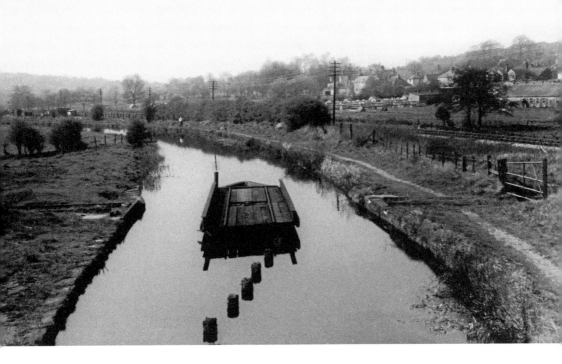

Mineral Line Turntable, Stanley Moss, 1920s

In the Caldon Canal, looking almost like a roundabout, is the base of a turntable built to allow a section of railway track to be swung into place over the water. This was part of a private mineral line that ran from Harrison and Son's Victoria Mill across the canal and then northwards alongside the main Stoke–Leek line. When no train was crossing, the swing bridge was locked into position in line with the canal allowing narrow boats to pass on either side.

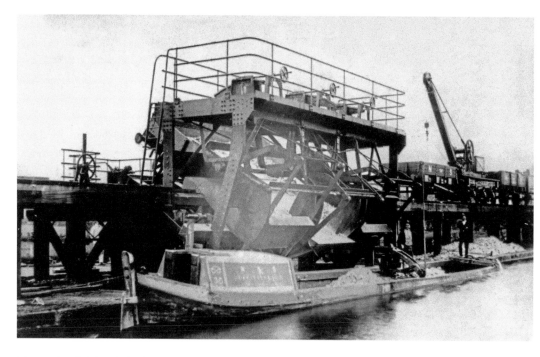

The Endon 'Tip' or 'Tippler', c. 1920

The 'Tippler' was constructed between a railway siding and the Caldon Canal. It tipped a railway wagon sideways allowing its contents to run down one of three chutes directly into a barge. It is alleged that its name was gained from the fact that it frequently tipped over and sank the barges it was loading but as it operated for around eleven years, this seems unlikely to be true. The place where the 'tippler' stood is now within Stoke-on-Trent Boat Club's marina.

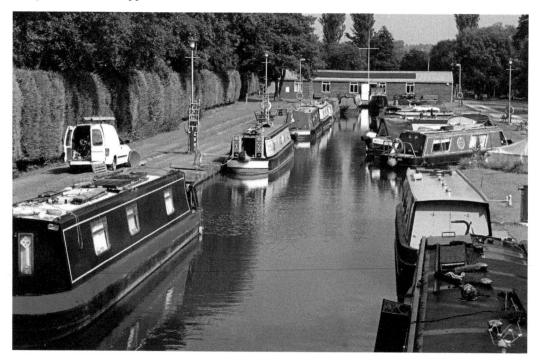

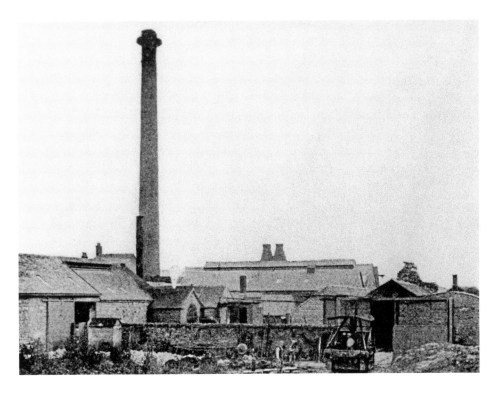

Victoria Mill, Stanley Moss, *c.* 1900

Harrison and Son, who supplied colours to the pottery industry, built Victoria Mill on the site of Stanley Forge in 1892. The mill was responsible for grinding previously prepared materials into very fine powders to be used in ceramic bodies and glazes. The mill closed in the 1970s and was later demolished. The site is now occupied by a cul-de-sac of stylish houses, Stanley Moss Lane, interspersed by older cottages and the former mess hall to the mill, itself now converted into a house.

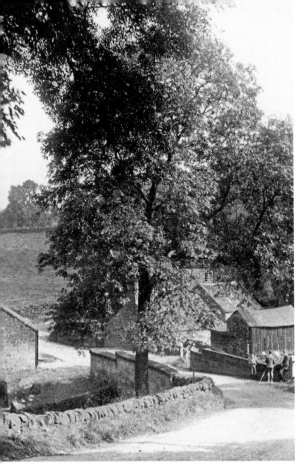

Old Stanley Road by Hercules Mill, 1920s

This slightly odd composition shows Stanley Road crossing the old bridge, in front of Hercules Mill, just visible on the extreme left, and going behind the house(s) also shown on the next two pages. Both the road and the bridge and most of the buildings shown have now gone. All that remains is the main mill building and what is now a single large house. The large tree fork at the top of the new photograph belongs to the same tree shown in the old one.

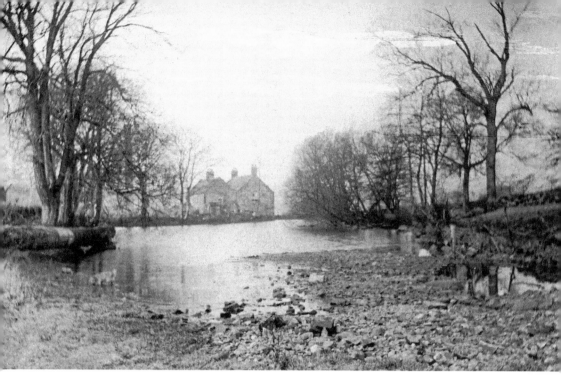

Millpond, Hercules Mill, *c.* 1910

This rather poor image shows the millpond that supplied Hercules Mill with its power. At this time, Stanley Road passed behind the house(s) visible at the end of the pool. The floods of 1927 saw all of that change. Today the millpond has a large wall separating it from the road and frequently hosts a pair of Kingfishers. The photographer seems to have branched out with this image and painted some clouds in. It is presumably his dog in the water.

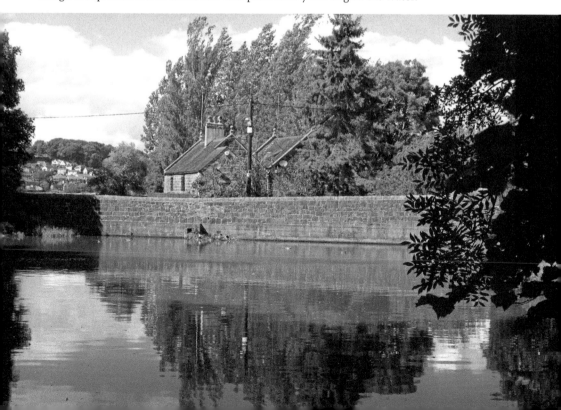

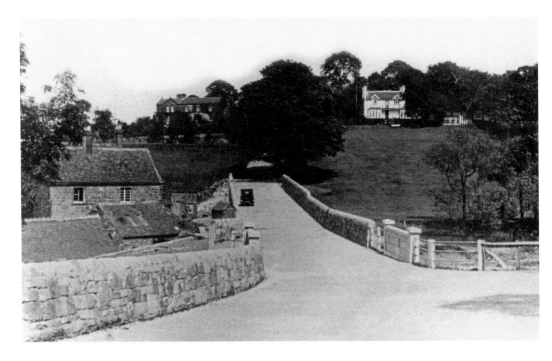

Stanley Road with New Bridge, 1930s

This photograph is taken from the junction of Puddy Lane with Stanley Road looking towards Stanley Bank. To the right is the millpond shown on the previous page). On the left is the entrance to Hercules Mill (now Corinthian Stone) with its now demolished outbuildings and the house beyond. The old Stanley Road can still be seen coming in from the left beyond the house, the straight stretch of road with its bridge and wall all having been constructed post-flood.

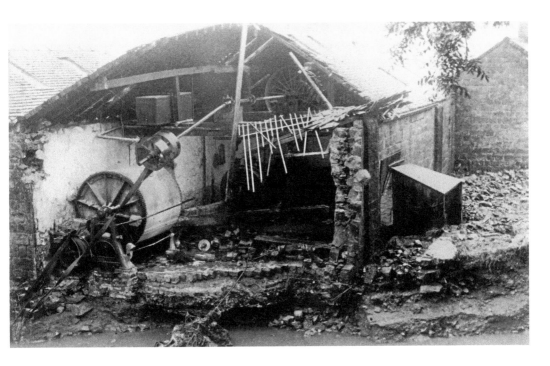

Hercules Mill Immediately After The 1927 Flood

This photograph shows how the end of Hercules Mill was torn off by the 1927 flood, exposing the machinery inside. The mill leet from the pond on page 53 is flowing right to left in the foreground. The new photograph shows how the end of the mill was rebuilt using brick in place of the original stone. On the right hand wall of both photographs can be seen the plaque shown as an inset on page 56.

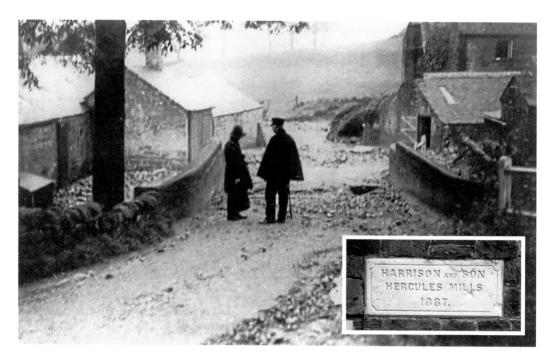

Hercules Mill Immediately After The 1927 Flood

This is another photograph taken at Hercules Mill immediately after the flood of 1927; this view shows the old road bridge and the road curving around the back of the house on the right. Huge numbers of stone pieces carried by the flood waters have been piled up against the front wall of the mill, and it is perhaps surprising that the mill was not more extensively damaged. The mill buildings on the right are no longer standing.

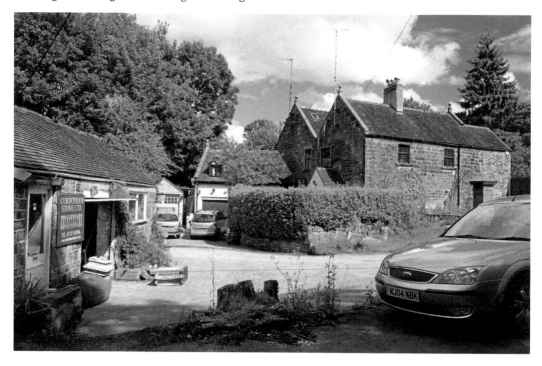

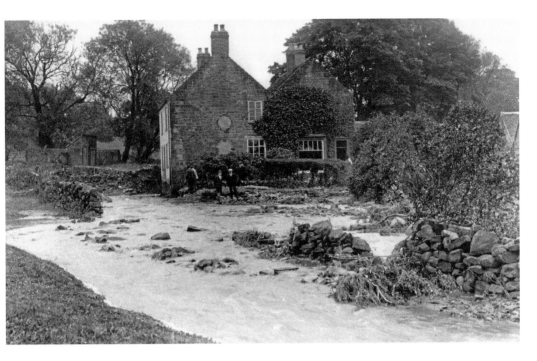

House by Hercules Mill, 1927

This is another photograph taken by Stanley Bebbington, the Manager of Harrison's Victoria Mill, in 1927. On the right is Hercules Mill, and the large house in the centre is the one that stands end on to Stanley Road today. At this time, Stanley Road still wound round the back of the house and behind the outside 'lavs' visible both here and in the photograph on page 54.

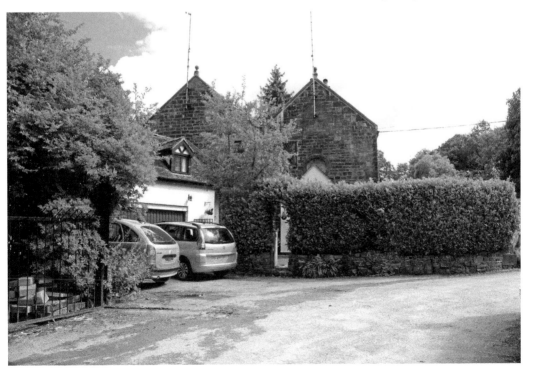

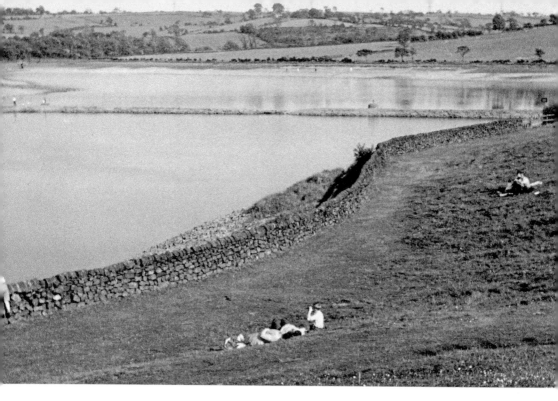

Stanley Reservoir with Original Dam Visible, 1950s

Stanley Reservoir (Stanley Pool) was created in 1786 to supply the summit of the Caldon Canal with water. It was originally eight acres in size, but in 1840, it was quadrupled in size to thirty-three acres. The original dam is still in situ and can be seen on both of these photographs taken in summer when water levels fall due lower rainfall and increased canal lock usage. The new dam was largely earthen and was severely eroded during the floods of 1927.

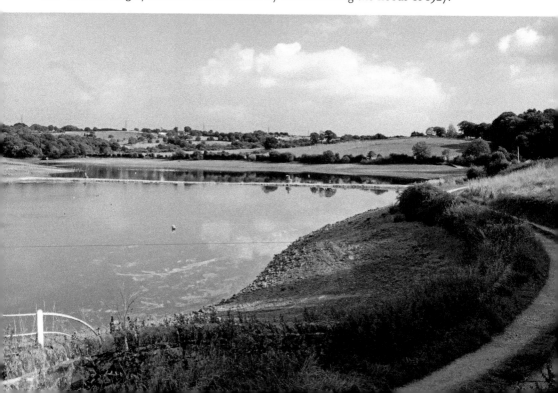

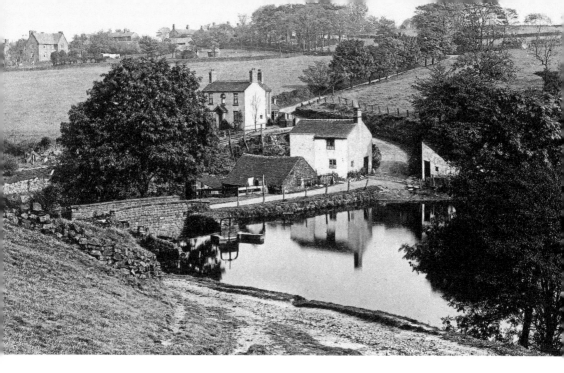

View of Stanley Village From Stanley Pool, 1920s

The old and new photographs here bear little resemblance to one another; the old photograph is entitled Stanley Village but today the village is completely obscured from here by mature trees. It can be seen from this photograph that there are two parallel bridges over the outflow from Stanley Pool, but the left-hand one is now easy to miss as you drive up Puddy Lane. The large house in the background 'with washing on the line' is Stanley Farm.

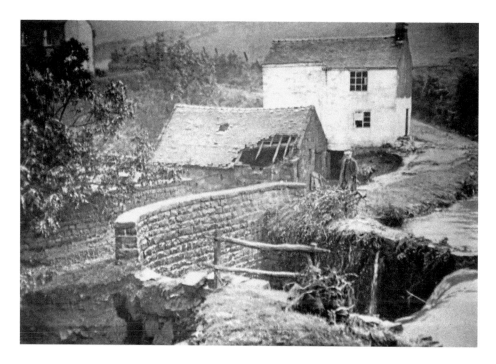

Puddy Lane, Stanley, 1927

This photograph shows Puddy Lane following the 1927 flood. Given how much ground has been washed away, it is a wonder that the bridge remained standing. The low building beyond it was a Gelatin(e) mill. Gelatin, produced by grinding animal bone (not hooves) would have been important to this photograph because silver salts suspended in gelatin and painted on to glass would have formed the negative that captured this image. Gelatin is also used as a gelling agent in foods such as jelly.

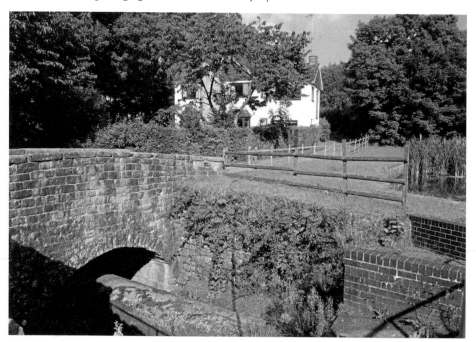

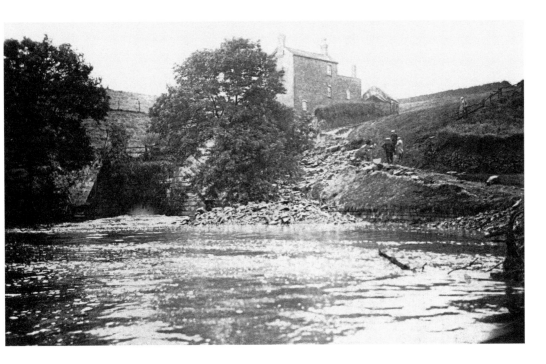

Dam from Puddy Lane, Stanley, 1927

This view of the new Stanley Pool dam in 1927 shows how water from the swollen reservoir had flowed over and around it with enormous force carrying many tons of stone down the slope to the bottom of the dam. The track to the water bailiff's house at the top, where the men are standing, was completely destroyed and needed to be reconstructed later. The dam had to be rebuilt in a different way to make it less susceptible to this type of damage.

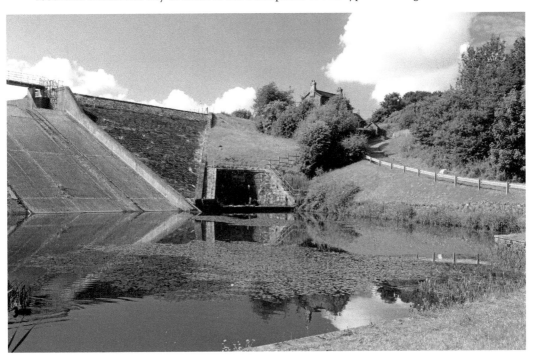

Spilsbury Farm, Stanley, c. 1910

This is one of several postcard images entitled 'A bit of Stanley'. It seems that the photographer had run out of really interesting Stanley subjects but needed to produce more cards. The resulting images are rather disappointing and the quality poor. This photograph shows Edward Clowes replacing a wheel on a float watched by his son. The farm has now been replaced by houses, but part of the barn wall survives as a boundary wall and can be seen on the recent photograph.

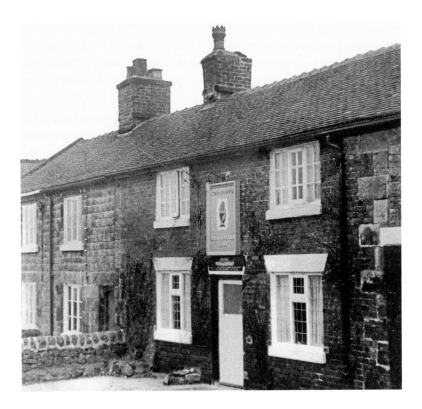

The Travellers Rest, Stanley, 1943

The Travellers Rest shown here in 1943 was a small establishment, increased in size later by the annexation of two neighbouring cottages. The pub was kept for many years by three members of the Mould family, although with a break between the first and the second. Members of the Mould family still live in the village. The Travellers Rest is now a very popular venue for meals, and in the sunny summer months, the tables outside are warm and very much in demand.

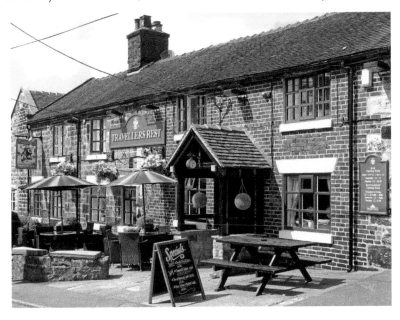

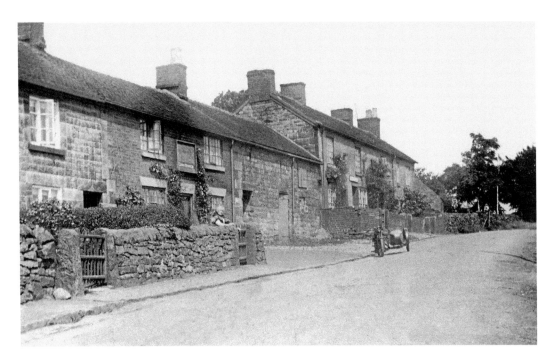

Stanley Village, 1930s

Meals were only served at the Travellers Rest on one night per year in the 1930s – Stanley Wakes Saturday night. Today there is no such thing as Stanley Wakes, and there are now probably only one or two nights per year when meals are not served. At this time, when Edwin Warren was the licensee, the pub had not yet occupied the cottage to the left and where there is now an archway leading to a large car park was still a cowshed.

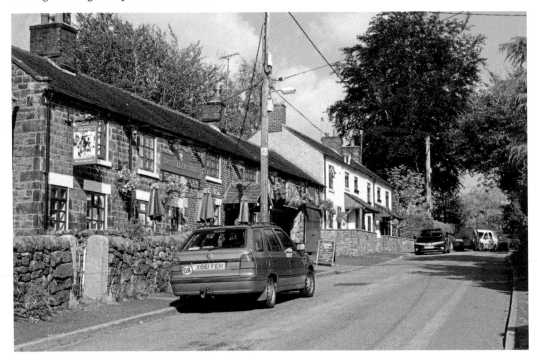

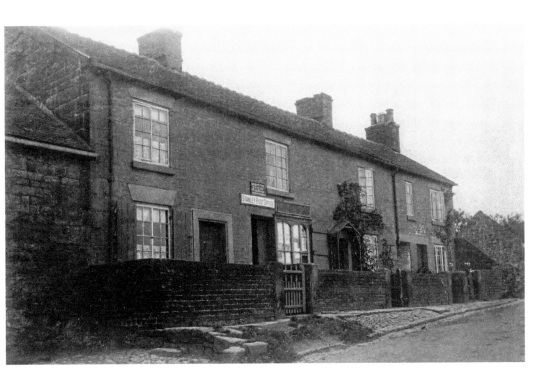

The Post Office, Stanley, 1920s

This is the block of houses above the Travellers Rest that contained Stanley's post office. As well as being the post office the building housed M. Griffiths, Grocer. By 1911 Ann Griffiths a 72-year-old widow was running the establishment. Today these cottages have had their windows replaced, had front porches fitted in some cases and been painted white, as well as being modernised inside. The one formerly housing the post office now goes by the name Post Office Cottage.

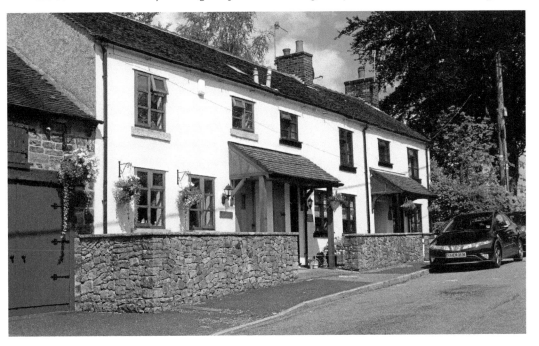

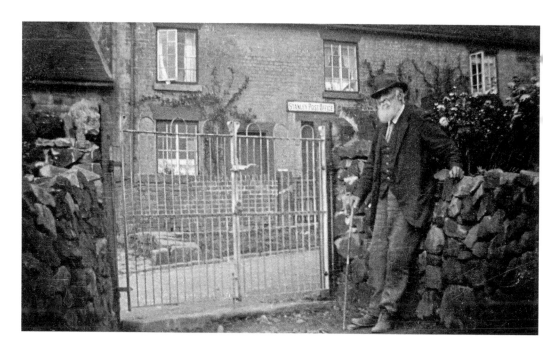

Edward Clowes at 'Wellcroft' Stanley, 1920s

This old photograph shows retired farmer Mr Edward Clowes at the gate of his house 'Wellcroft' in Stanley. At the back of the house was a cobbler's shop and on the opposite side of the road the village post office (see previous page). Today Stanley has no shop, no cobbler's, no post office and since St Agnes' Mission closed no place of to worship. The nearest churches now are the United Reform Church at Tomkin or St Chad's at Bagnall.

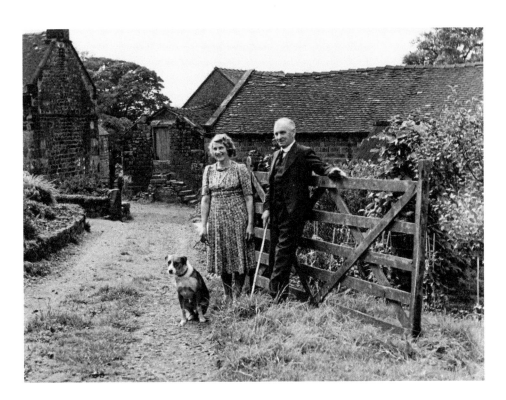

Stanley Head Farm, 1950s

This photograph shows William and Mildred Myatt at Stanley Head Farm. When Mr Myatt retired in 1967, their 65-acre farm was sold to Stoke-on-Trent Corporation. The farmhouse and outbuildings were converted into the headquarters of Stanley Head Outdoor Education Centre. The plan was to keep ten acres of land for use by the centre and for the other 55 acres to continue in agricultural use. The centre enables disabled and disengaged children to take part in activities such as rock climbing and sailing.

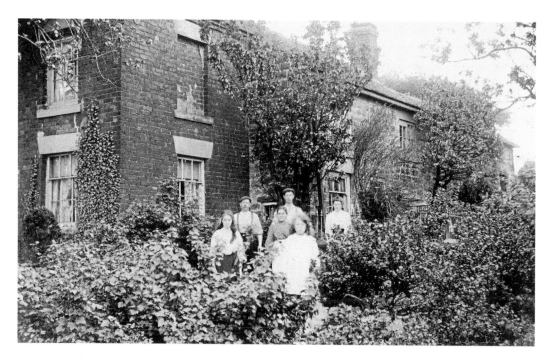

Smithy House, Tomkin, *c. 1915*

This pair of photographs is an example of how change is not necessarily for the better. The old image shows William Perkin and his family in the garden of Tomkin Smithy House. William and Sarah clearly felt proud of their house, garden and four present children. William and Charley were blacksmiths, and Charley went on to become Champion Blacksmith of all England. The modern photograph shows that the house is now virtually unrecognisable with none of its previous character or charm.

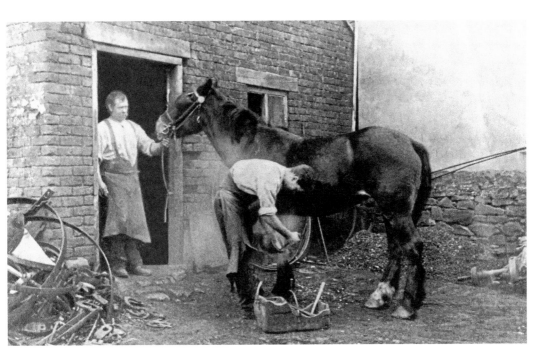

Tomkin Smithy, c. 1910

In this old photograph, young Charles Perkin shoes a horse at Tomkin Smithy, while his father William tries to prevent any objections the horse might have to the procedure. At the same time that the smithy house was so drastically altered, the smithy itself was converted into a garage with double doors. The present owner rebuilt the smithy on its original footprint, and it was only the appearance of the smithy today that enabled the house to be recognised.

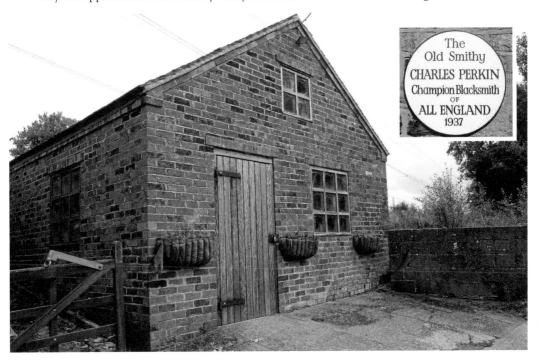

Bagnall Ford and Springs, 1920s

Although the ford and the spring themselves are largely unchanged, this view has altered dramatically today because of the number and size of the surrounding trees. This photographer took at least two photographs of the spring and included the young girl, probably his daughter, in both of them. The car in the distance may also have been his. The stone-built well house is Grade II listed and bears the inscription 'A.D. 1811' 'PUBLIC WELL S.R.S.A'. – 'REFIXED 1891'.

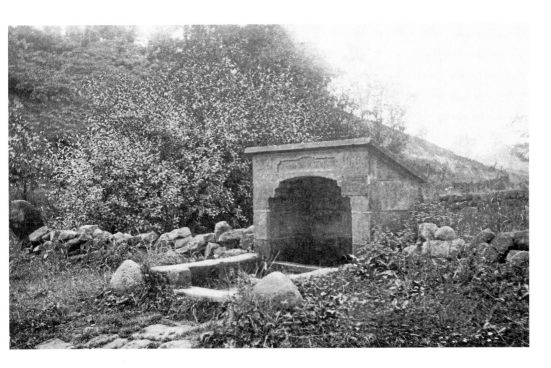

Bagnall Springs Close-up, *c.* 1910

This photograph is a closer view showing the well house on Springs Bank, Bagnall. The abbreviation S.R.S.A. in the inscription (see previous page) stands for 'Staffordshire Rural Sanitary Authority'. There is a similar stone well house with this inscription in Washerwall Lane, Werrington. The recent photograph was deliberately taken from the opposite side in order to also show the ford and the footbridge over it. Sanitary authorities were also responsible for things like street cleaning, controlling sewers, clearing slum housing and regulating slaughterhouses.

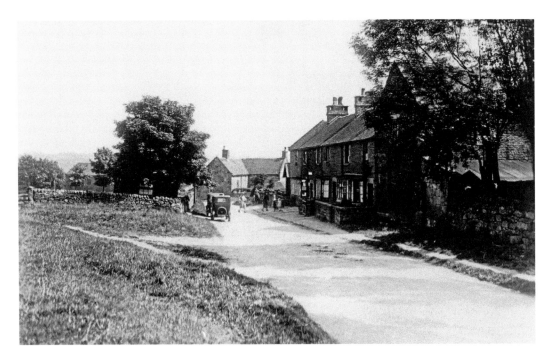

The Cottages, Bagnall, 1920s

This scene has changed little in the ninety or so years since the old photograph was taken. The cottages have now had tiled roofs put over their bay windows, and the shop visible at the far end of the row in the old photograph is no longer in existence. Beyond the cottages is the old St Chad's Church Hall demolished only three weeks before the time of writing and replaced by the steel frame for a new house.

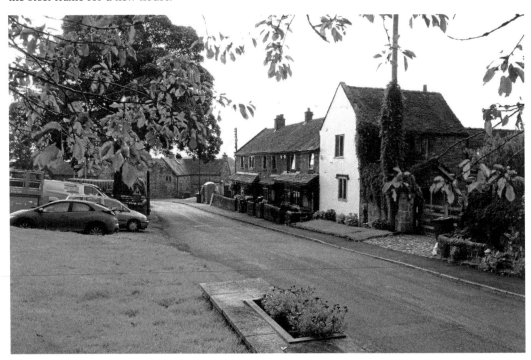

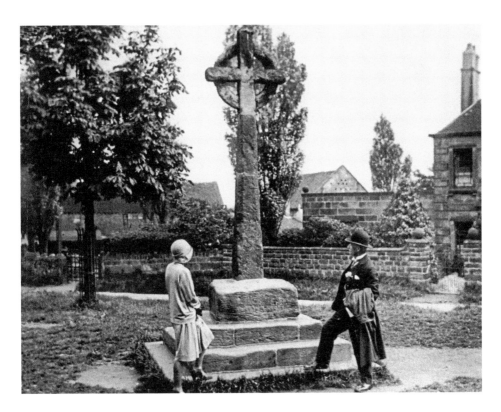

Bagnall Hall, *c.* 1930

The old photograph shows a couple who may have just been married at St Chad's church. On the right can just be seen a small part of Bagnall Hall, the oldest image that has so far been uncovered of any part of it. The original hall was built in 1593 for James Murrall, later Sir James, and was twice the size it is today, with a clock tower. The hall was later extensively damaged by fire and was rebuilt in 1777.

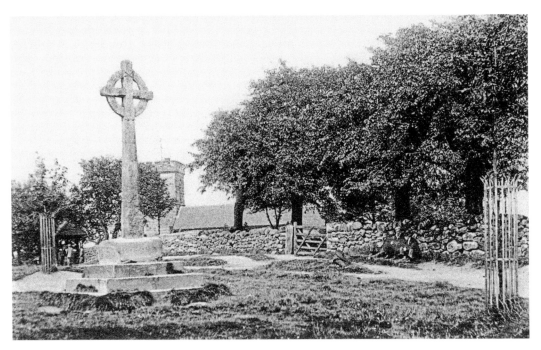

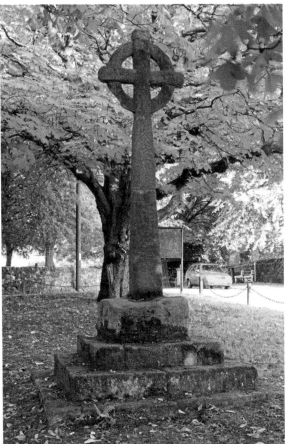

Bagnall Cross, 1906

This view of Bagnall Village Green and its restored sixteenth-century Cross is almost unrecognisable today. Beyond the cross is St Chad's church, today completely obscured by mature trees. The two saplings in metal guards are Horse Chestnuts, two of five named after Queen Victoria's daughters Victoria, Beatrice, Helena, Louise and Alice and planted in June 1897 to commemorate their mother's Diamond Jubilee. Today in summer, the cross is easy to miss, so hidden is it by these trees.

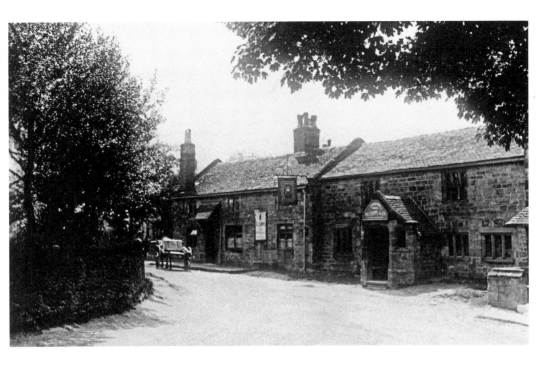

The Stafford Arms, Bagnall, c. 1905

The precise date that the Stafford Arms was built seems somewhat confused, but what is certain is that it is a very old pub. It was formerly called the Kings Arms, and like the Travellers Rest in Stanley, it has increased in size over time by moving into adjacent buildings and outbuildings. As well as the cottages next door, the old stables have also been incorporated into the premises and now hold the Stables Dining Room.

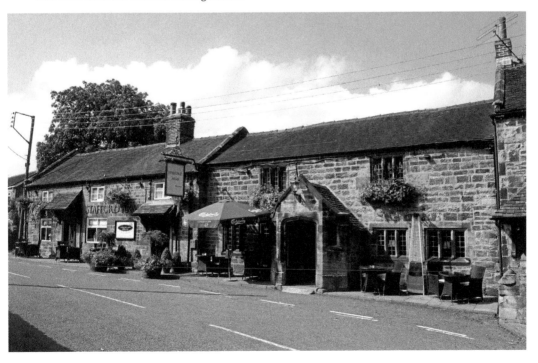

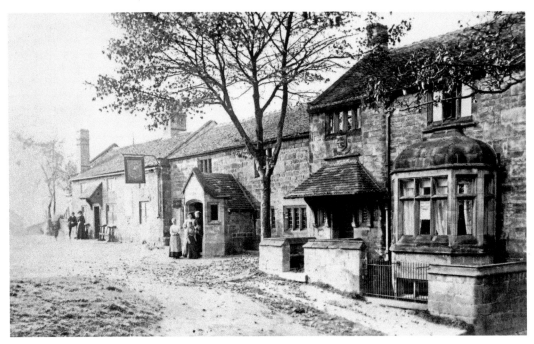

St Chad's House, Bagnall
St Chad's House is the only part of this block not part of the Stafford Arms. It was built in the 1600s and was formerly the rectory to St Chad's Church. It was substantially remodelled in 1808 by the Owen family of Wrexham, patrons of the church. Above the door are the arms of the Owen family and the motto (in Welsh) translates as 'What Owen Has He Holds'. The poster in the window advertises a 'Conversational Dance' to take place at the Council Schools.

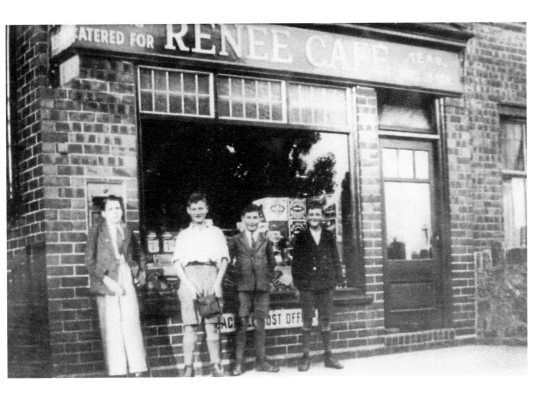

Bagnall Post Office and Renee's Café, 1930s

Bagnall has no post office now, but in the 1930s, it stood opposite the green and doubled up as Renee's café. As with both Endon and Stanley, the old post office in Bagnall gives a clue as to its identity by being called The Old Post Office. It also has a phone box outside and set into the wall a postbox, now painted black and disused. The current postbox, outside St Chad's church, is painted gold in honour of medal-winning disabled Olympian Lee Pearson.

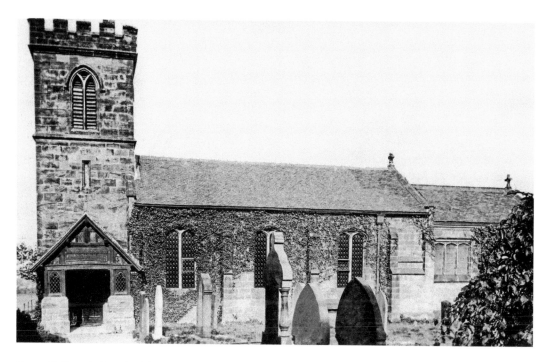

Bagnall Church (St Chads) 1911

The present St Chad's Parish Church was built in 1834 because its predecessor, with its wooden tower, was in such a poor state of repair. That church, St Michael's, had been built in the Middle Ages. Alterations to St Chad's were made *c.* 1880 when the bell tower and chancel were added. The chancel was funded by the Revd Samuel Hubert Owen, whose family's arms adorn the front of St Chad's house (see page 76).

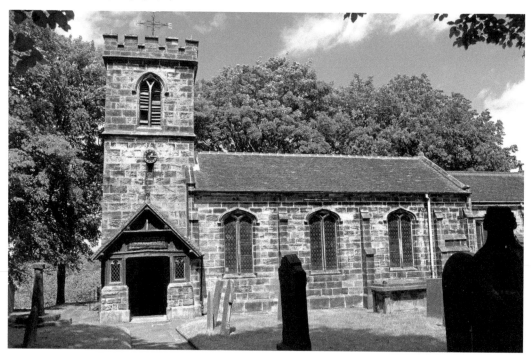

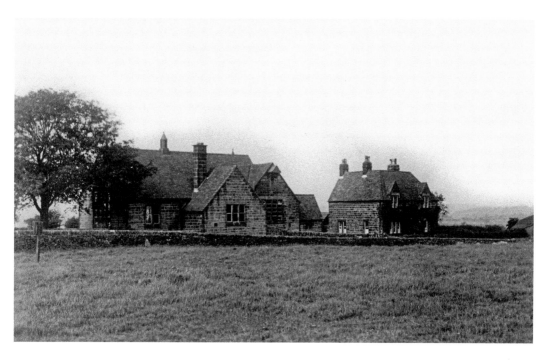

Bagnall Council Schools, 1920s

This view of Bagnall Schools cannot be replicated today because the field from which it was taken has been built on. It shows the Council Schools, built in 1874, on the left and the Headmaster's house on the right. The school, by then named Moorlands County Primary School, was gutted by fire on 16 March 1969 and, having been deemed unsafe, was demolished shortly afterwards. The Headmaster's house now forms the front of the Bagnall (Moorlands) Village Hall.

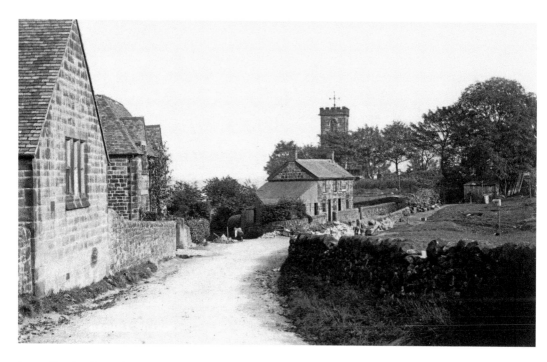

Bagnall Schools and Church, 1920s

This photograph too cannot be precisely replicated today because of mature tree growth. The old Headmaster's house still looks the same, having been restored in 1975. The cottages on School Road look the same, but St Chad's Church is now completely obscured from here by trees. The workman with his back to the camera is possibly laying a band of granite setts (cobbles) across the top of Clewlows Bank.

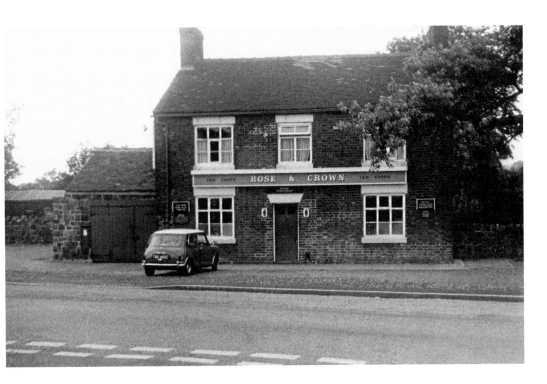

The Rose & Crown Stanley Moor, 1968

The Rose & Crown is a conveniently placed country pub standing on the junction of Clewlows Bank and Stanley Road. This makes it easy to reach from Bagnall, Endon, Stanley or Stockton Brook. It is a popular venue for lunches and commands a spectacular view of the valley through which the proposed Stoke–to–Leek railway, Caldon Canal and the main A53 Potteries to Leek road run. The old photograph shows the pub *c.* 1960 when it was run by Mr and Mrs Pickering.

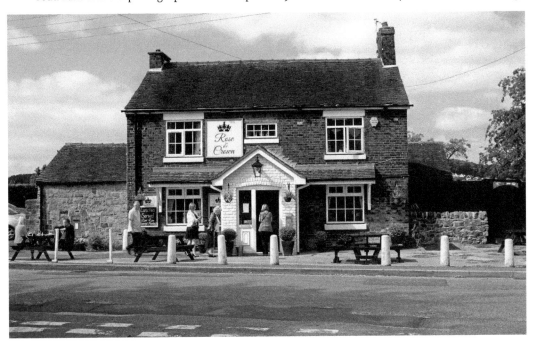

Stanley Road Looking Towards the Rose & Crown, *c.* 1925

This old photograph shows a scene which on the surface appears to have changed very little although there have actually been significant changes. The bungalows have been either extended or completely rebuilt, the furthest one, Hilltop, now being a large house. Beyond the cottages in the distance, there is also now a row of varying properties all the way to the Rose & Crown where previously there had been only small fields.

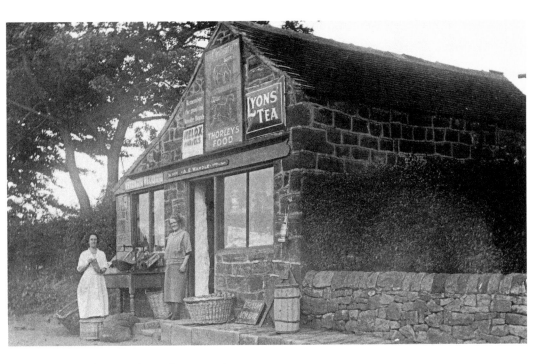

Shop, Stanley Road, Stockton Brook, c. 1910

This wonderful old photograph shows the shop run by A. E. Wardle on Stanley Road at the very edge of Stockton Brook. It sold everything from loose apples and Tilley lamps to Melox Marvels (dog biscuits). The shop probably benefited from people walking between Stockton Brook and Stanley but was not in the best location once people became more mobile. More recently, the shop was run as an antique shop by its present owner who says that officially it is still a shop.

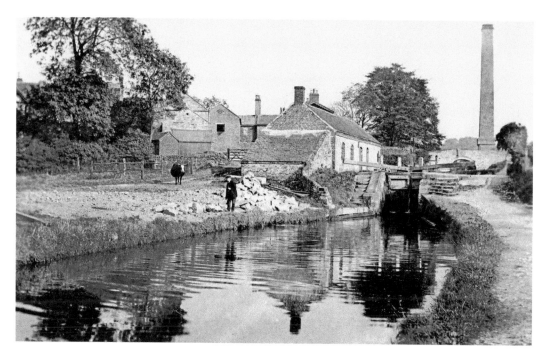

Stockton Brook Locks, *c.* 1911

This photograph shows the top lock of the Stockton Brook flight, after which the Caldon Canal is at its summit. Beyond the lock is the Stanley Road Bridge, so narrow that a separate metal pedestrian bridge had to be constructed parallel to it. The chimney on the right belongs to a brick works, now buried by mature woodland. Just visible between the buildings is a large Georgian house that has stood derelict for decades but hopefully may soon be restored.

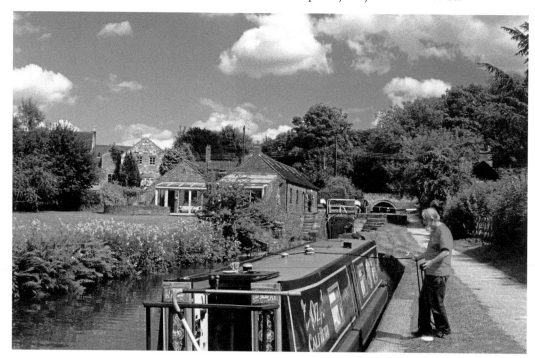

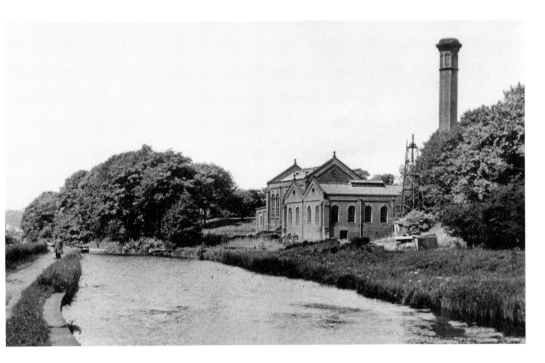

Stockton Brook Pumping Station, 1920s

Stockton Brook Pumping Station was built in 1884 to pump water up from a borehole. In 1936, its original steam engines were replaced by electric motors, which made its tall chimney redundant. The chimney was not demolished until much later and was apparently largely left lying in the woods to the rear. It is now in private ownership and has been re-roofed, the intention being to fully restore the building, remove the machinery and open it as a venue for corporate events and weddings.

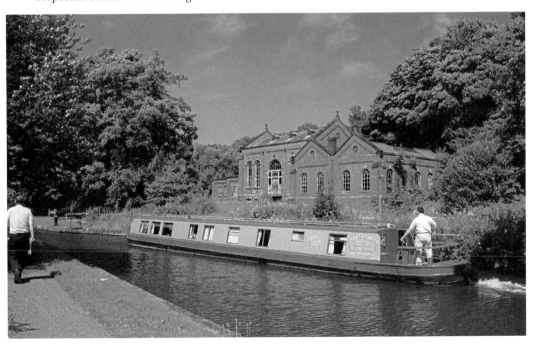

View of Stockton Brook from the Golf-Links, post 1909

On the old photograph Stockton Brook's Post Office with its conical tower lines up with the bowling green behind the Hollybush. The area from where the old photograph was taken is now covered by trees. The 2015 equivalent was taken from the opposite side of Greenway Bank Golf Club's eighteenth green, looking in the correct direction but showing just how little of the surroundings are visible today because of tree-growth. The recent photograph shows the edge of the building site at the edge of the course.

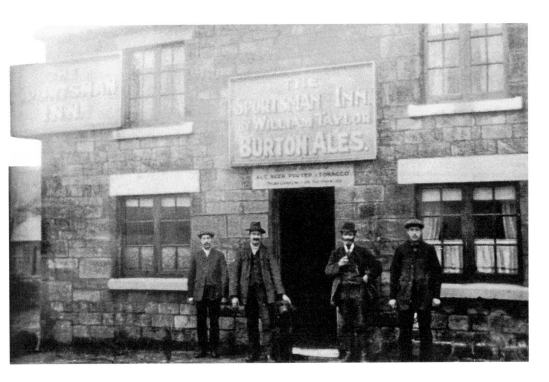

The Sportsman Inn, Leek Road, *c.* 1900

The two old photographs of The Sportsman included here have not benefited greatly from being kept in the Lounge window, and the images will no doubt disappear altogether before too long. Unfortunately, the name of the licensee cannot be read on this photograph, making it difficult to date with accuracy. If any of these gentlemen was the licensee, then it seems almost certain to have been the spectacularly moustachioed man on the right of the door.

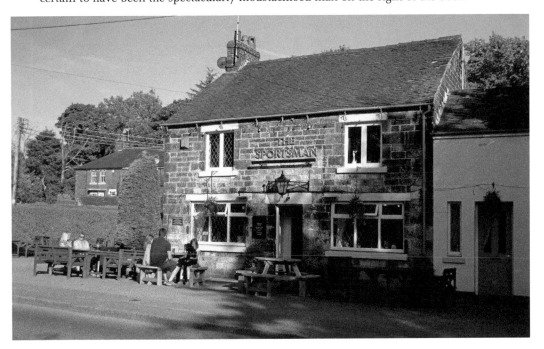

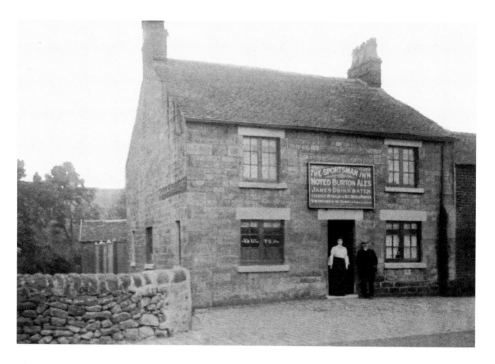

The Sportsman, Leek Road, *c.* 1910

The signage on this second photograph of The Sportsman Inn is markedly different from the previous page. The licensee's name can clearly be read: James Drinkwater, rather an inappropriate surname for a man wanting his clientele to partake freely of his 'Noted Burton Ales'. At one time, 'mine host' was Reuben Kent part of the Kent family of Cheddleton who at various times ran the brewery there, the Red Lion and The Fox. (See *Cheddleton & District Through Time*.)

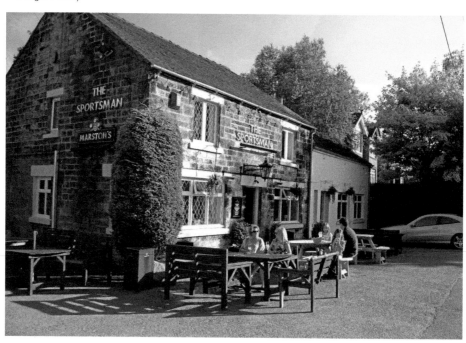

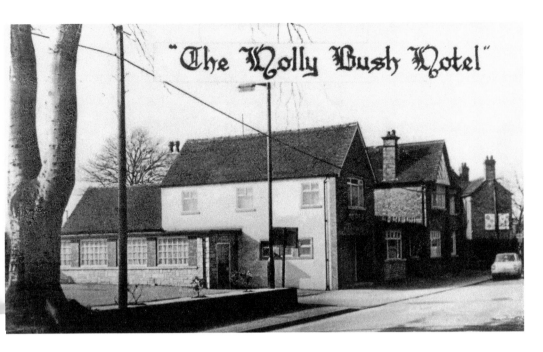

The Hollybush, Stanley Road, 1960s

The building that occupies this spot today is not called The Hollybush, as it was when kept by the Joddrell family in the old photograph, but 'Ego, Mediterranean Restaurant and Bar at The Hollybush'. It is probably a safe bet though to know what people actually call it though. It has been greatly enlarged and much changed since being built, as the photographs show, but ever since the early 1900s, there has been a bowling green behind the building (see next page).

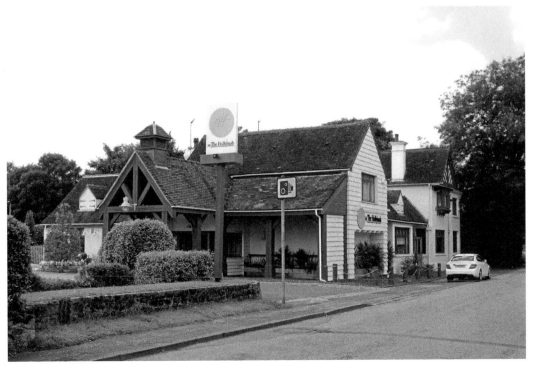

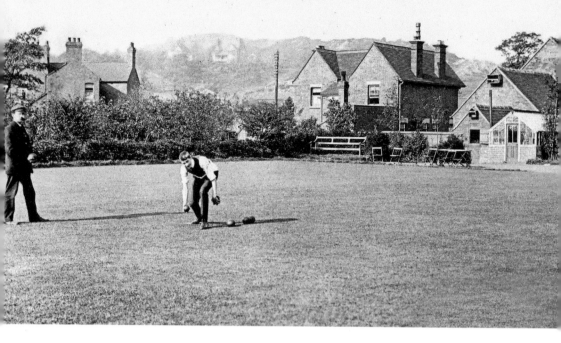

The Hollybush Bowling Green, c. 1910

It was not easy to tell at first whether 'The Bowling Green, Stockton Brook', was the same green that exists today behind The Hollybush, but eventually, the large house on Heather Hills in the distance was identified, confirming that they were one and the same. As well as the bowling green, the Hollybush also had a tennis court at the beginning of the twentieth century and was at the centre of village life. The Joddrell family were licensees there continuously for sixty years.

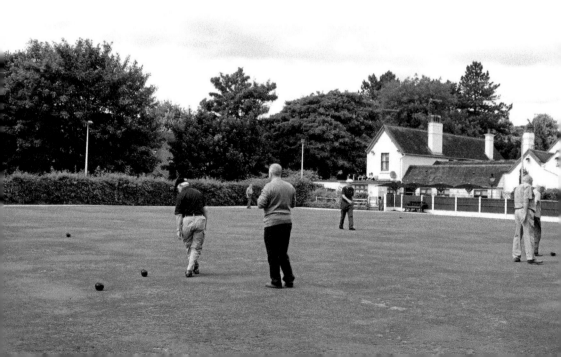

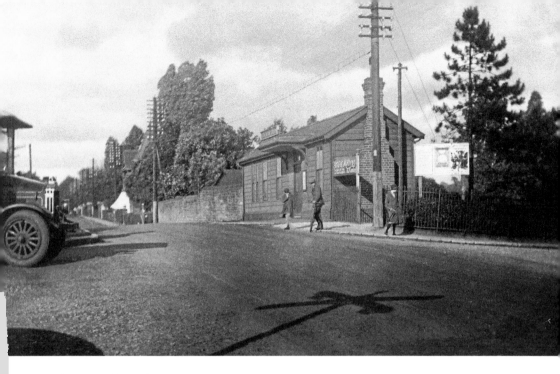

Stockton Brook Station, *c.* 1914

Stockton Brook Station, pictured here, opened to passengers in 1896, although the line it served had already been open for nearly thirty years. It was initially called 'Stockton Brook for Brown Edge'. Like Endon, the station closed in May 1956 although freight continued to be carried on the line until February 1989 Posters outside advertise rail trips to Swansea and advise passengers to 'Eat it at McIlroy's' in Hanley. The wooden station building is now a kitchen and bathroom shop.

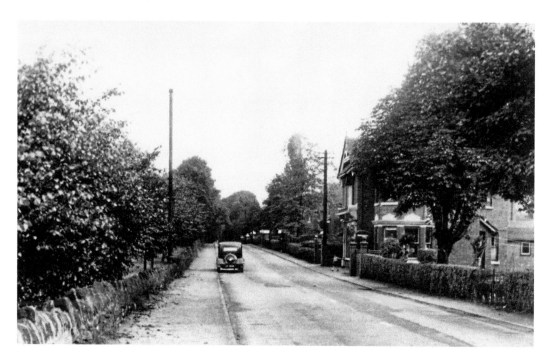

Leek Road, Stockton Brook, Post Office on Right, 1930s

The tree obscures the most striking feature of the old Stockton Brook Post Office, its conical-roofed tower, of which only the base can be seen. The tree was taken down when the present single-storey post office was built so a similar shot today shows the tower clearly. The tower used to be visible from a long distance and enabled people to orient themselves in the landscape, but today Stockton Brook as a whole is heavily obscured from a distance by trees.

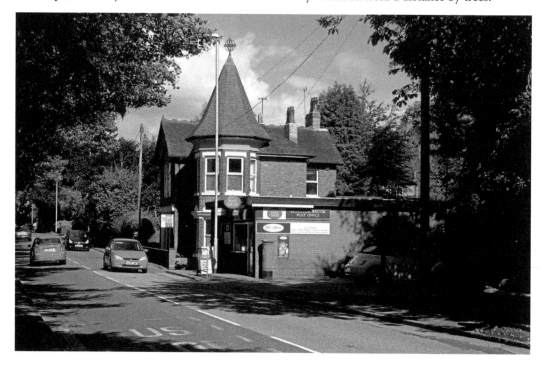

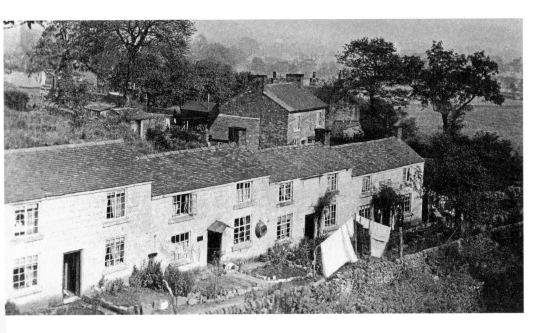

Waterfall Cottages, Basnett's Wood, *c.* 1910

Another photograph that cannot be precisely replicated because of tree growth, Waterfall Cottages look very different today as there are now only three and the highest of the three was substantially altered in the 1980s. In the background, the nearest building in the old photograph has been demolished, but the attractive Spring Cottage beyond it still stands, surrounded by new housing. The brook on which the waterfall stands runs across the front of the cottages just over the wall in the foreground of both photographs.

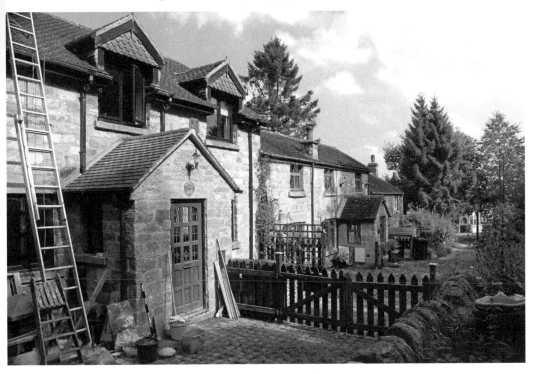

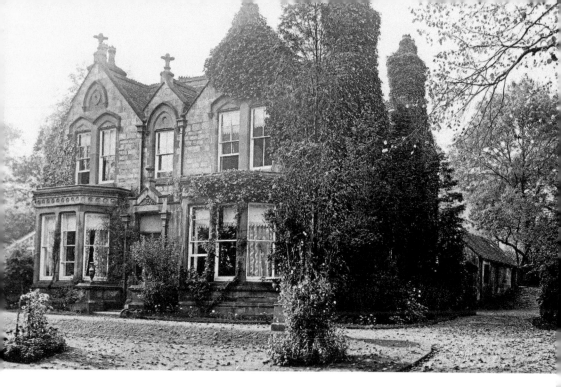

Endon Hall, Undated

Endon Hall was built in the mid-nineteenth century and remodelled in the 1870s. In the 1950s, the hall was purchased by Mr Roland Kent who demolished it and had Kent Drive laid along the course of the former drive. The trees now forming the right-hand boundary of Kent Drive were probably originally planted along the hall drive. The road surface unusually is made of concrete probably another original feature of the development.

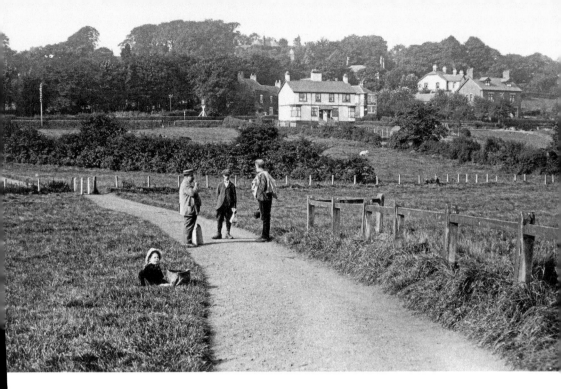

View from the Meadows Towards the Plough

One of these men might be saying to the other 'I remember this when it were all fields'. The change he would be referring to would be the pair of houses that nearly obscure The Plough from where they were standing. Today there are so many houses in the area that not only can The Plough not be seen from here but nor can the houses mentioned above. On the recent photograph, only their roof and chimneys can be seen above the newer properties.

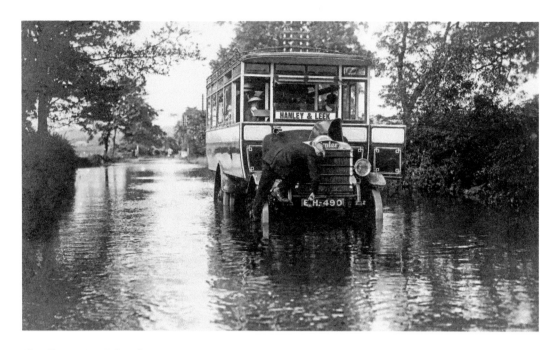

Flooding on Leek Road, *c.* 1913

This photograph shows one of the floods that frequently paralysed the main Leek–Hanley road when heavy rain caused the Horton Brook to overflow its banks and spill across the road. In this scene, the driver of Daimler Bus EH490 has clambered out of the driving seat and balances precariously trying to restart the engine using the 'cranking handle' – without getting his feet wet. The passengers wait inside wondering whether they will eventually be forced to paddle to dry land.